M000248051

A History of

GEORGIA
RAILROADS

Robert C. Jones

THE
History
PRESS

Published by The History Press
Charleston, SC
www.historypress.net

Copyright © 2017 by Robert C. Jones
All rights reserved

First published 2017

Manufactured in the United States

ISBN 9781467137775

Library of Congress Control Number: 2016956929

CONTENTS

ACKNOWLEDGEMENTS

Dustin Klein, archivist of the Southern Museum of Civil War and Locomotive History in Kennesaw, Georgia, who helped me parse through the David Salter Collection for appropriate photos.

David Ibata, editor of the *Dixie Flyer*, a NC&StL Preservation Society publication, who provided steam photos of the NC&StL operating on the old W&A in northern Georgia.

Dan Berman, Craig Bicknell, John Marbury and Pete Silcox, all of whom were on my panel of retired railroad executives.

Finally, Debra Kasson-Jones, who proofread the manuscript.

INTRODUCTION

They're all gone now—all of the nineteenth-century Georgia railroads and even most of the twentieth-century ones. Oh, there are still some depots standing, as well as other railroad buildings. A tunnel here and a bridge there might date to the nineteenth century. But the railroads are gone, either absorbed into Norfolk Southern (NS), CSX or Amtrak—or simply abandoned and deserted.

It used to be possible to take a train (as a passenger) from just about anywhere in the state of Georgia to anywhere else in the state of Georgia! Wouldn't that be a blessing in today's traffic gridlock? But alas, except for a handful of Amtrak trains and MARTA, you can't really get *anywhere* by train in Georgia anymore.

Consolidation in the name of efficiency has been the name of the game in the last fifty years, as well as the diminution of passenger service. And while the two Class I railroads serve the state of Georgia *efficiently*, perhaps innovation and (to some extent) competition have been sacrificed.

Of course, in the nineteenth century, especially in the pre–Civil War days, people didn't worry too much about efficiency but rather about building out a network of rail. Pre–Civil War railroad building in Georgia often consisted of one or more entrepreneurs, or perhaps city officials from one or more towns, deciding, "Let's build a railroad." They invariably found three hard truths of railroad life:

- railroads are hard (and expensive) to build;
- railroads are hard (and expensive) to operate and maintain;
- and an isolated railroad line between two small towns in the middle of nowhere is likely to be unprofitable.

It would make sense to have a larger strategic picture than many of the small railroads had when they started building. Perhaps a plan to tie together major cities and towns along a route—in Georgia, this might include Augusta, Atlanta, Macon, Albany and Savannah. Understanding the freight opportunities along a route would be important—would the target market be agricultural? Finished goods? Raw materials? Linkages with other established railroads would be important, too. For example, your customers might want to travel from Atlanta to Chicago, or Savannah to Philadelphia, without changing trains and railroads multiple times. All of these ideas would come into play when the big corporations took over in the latter part of the nineteenth century.

There were about ten railroads in Georgia on the eve of the Civil War, but five would play an especially significant strategic role in the major battles and campaigns of the war in Georgia: Atlanta & West Point, Central Railroad, Georgia Railroad, Macon & Western and Western & Atlantic. We'll examine each of the five and their destruction by William Tecumseh Sherman in 1864. We'll also examine what happened to each of them after the war, as well as into the twentieth and twenty-first centuries. Next, we'll examine other nineteenth-century railroads in Georgia that had a big impact on the state and/or a significant amount of trackage. And we'll examine individual entrepreneurs, such as Henry Plant and Thomas Clyde, who were bona fide railroad tycoons and had a great impact on nineteenth-century railroading in Georgia.

By the twentieth century, new, mega-railroads had taken over Georgia, including one new entry created out of whole cloth by J.P. Morgan: the Southern Railway. But the Louisville & Nashville, Seaboard Air Line, Atlantic Coast Line and the combined Seaboard Coast Line were major players as well. Through mergers, acquisitions, bankruptcies, consolidation and the creation of a national passenger railroad, by the end of the twentieth century there were, essentially, only three major railroads in Georgia: CSX, Norfolk Southern and Amtrak. We'll take a look at these railroads as well.

To add a little real-life experience-flavor to the book, I'll be adding some quotes from a panel of retired railroad executives, including the following:

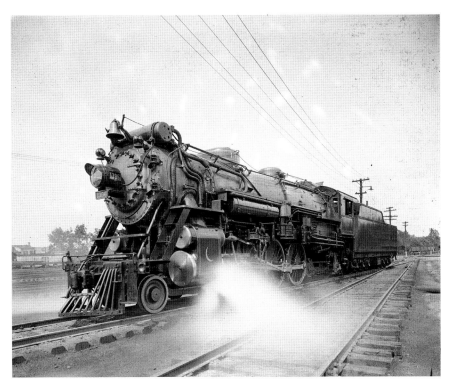

"Southern R.R. Co. Crescent Locomotive," circa 1916. *Courtesy Library of Congress.*

DAN BERMAN, who joined Southern Railway in 1962 as a graduate from Yale with a transportation degree. He rose from track supervisor to director of car utilization in his more than twenty years with Southern Railway. All told, Dan served for thirty-two years with Southern Railway and Norfolk Southern.

CRAIG BICKNELL, who started out in railroading with Conrail and moved to Norfolk Southern when NS and CSX carved up Conrail between them. He retired in 2015 as the NS manager of Car Hire and Equipment Planning Group.

JOHN MARBURY, who was manager of signal operations in Atlanta when he retired from NS in 2000. He still works as a contract project manager for NS. He served sixteen years as a project manager for construction for the Southern Railway and then Norfolk Southern. He once served as yard supervisor at Inman Yards for the Southern Railroad.

PETE SILCOX, who worked for the Georgia Railroad, the Seaboard Coast Line and CSX from the time of its creation until his retirement in

2007. During his thirty-six-year career, he worked in design (engineering), supervised field construction, office management and a track inspection training program. Upon his retirement with CSX, he was manager of the track inspection program.

Some notes on nomenclature might be in order. Often (although not always), company names were changed from *railroad* to *railway* after getting out of receivership.

There are a few theories about where the term *air line* when used for railroads (such as Seaboard Air Line Railroad) came from. One is that this referred to companies that used both railroads and ships for their transportation system (sailing ships were propelled by wind). Another is that *air line* referred to the closest path between two points on a map.

Chapter 1

Key Players

E. Porter Alexander

E. Porter Alexander was a Georgia boy through and through—he was born on May 26, 1835, in Washington, Georgia. It is only fitting and proper that he would have such an impact on the post–Civil War railroad panoply in Georgia.

Before his railroad career, he was in the military. In 1857, he graduated third in his class from the United States Military Academy at West Point as a second lieutenant of engineers (brevet).

In 1861, on the eve of the Civil War, he worked as an engineer in the construction of the defenses of Alcatraz Island in San Francisco Harbor. By May 1, 1861, he had resigned from the U.S. Army, and on June 3, 1861, he became the chief engineer and signal officer of the Army of the Potomac. He was promoted to major on July 1, 1861.

On July 21, 1861, during First Bull Run, Alexander became the first person to use signal flags to transmit a message during battle.

In 1862, Alexander, now a lieutenant colonel, became chief of ordnance under Joseph Johnston and then Robert E. Lee. It was Alexander who, on December 11–15, 1862, managed artillery on Marye's Heights at the Battle of Fredericksburg that proved so devastating to the Union troops under Ambrose Burnside. From April 30 to May 6, 1863, Alexander managed the

artillery on Stonewall Jackson's flanking attack at Chancellorsville. But his greatest moment as an artillery officer occurred on July 3, 1863, when he commanded the artillery barrage before Pickett's Charge. It was the largest artillery barrage in the history of warfare up to that time.

On February 26, 1864, Alexander was promoted to brigadier general. He was present at Lee's surrender to Grant at Appomattox Court House on April 9, 1865.

It is his postwar activities, though, that have the most interest for this book. After a spell teaching mathematics at the University of South Carolina in Columbia (1866–69), he began a period of fifteen years where he held executive positions at six different railroads, including:

- 1871–72: executive superintendent of the Charlotte, Columbia & Augusta Railroad
- 1872–75: president of the Savannah & Memphis Railroad
- 1875–78: president and general manager of Western Railroad of Alabama
- 1878–80: president of Georgia Railroad and Banking Company
- 1880–82: vice-president of the Louisville & Nashville Railroad
- August 1882: president of the Central Railroad (ousted in December 1882)
- December 1886: president of the Central Railroad

In 1887, he authored the book *Railway Practice*. Alexander published his memoirs (*Military Memoirs of a Confederate, A Critical Narrative*) in 1907. He died on April 28, 1910, in Savannah, Georgia.

Governor Joseph E. Brown

Joseph E. Brown served as both senator and governor of Georgia, but he is most famous for his time as the latter. He was a leading secessionist and helped guide Georgia out of the Union on January 19, 1861. Brown served as governor of Georgia throughout the Civil War.

Once Georgia had seceded, though, Brown would be a thorn in the side of Jefferson Davis throughout the whole war. As a strong believer in states' rights, Brown generally refused to cooperate with the centralized Confederate government or even the Confederate army. He opposed any attempt to draft

Georgia soldiers into the Confederate army, preferring them to be members of the Georgia State Militia. The militia would see extensive action during Sherman's March to the Sea (most famously at Griswoldville).

After the war, Brown would be involved in various business interests that might raise an eyebrow today from an ethics standpoint. A group led by Brown leased the state-owned Western & Atlantic Railroad in 1870, and Brown became president. This arrangement lasted for twenty years, until the Nashville, Chattanooga & St. Louis Railway took over the lease in 1890. Also, Brown would become rich using convict labor to mine coal in Dade County in the 1880s and 1890s.

Brown served as chief justice of the Supreme Court of Georgia from 1865 to 1870 and as U.S. senator from Georgia from 1880 to 1891.

THOMAS CLYDE

Thomas Clyde, born in 1812 in Philadelphia, Pennsylvania, was both a successful steamship operator and a railroad baron of some note. He was the driving force behind the Piedmont Air Line Route, one of the first attempts at marketing a route rather than a railroad.

Clyde's first successful business venture was in the steamship business. In 1844, Clyde Steamship Line was established, linking Philadelphia with the rest of the East Coast. In the same period, Clyde built the first screw-driven steamship in the United States (paddle-wheel boats were the norm at the time).

His entry into the railroad business began in 1873, when he bought the bankrupt Richmond & York River Railroad, which ran from Richmond to West Point, Virginia, one of Clyde's steamship ports. In 1874, he formed the Baltimore, Chesapeake & Richmond Steamboat Company, whose purpose was to operate steamships from West Point, Virginia, to Baltimore, Maryland. This proved to be a highly profitable venture.

In 1875, Clyde purchased the Richmond & Danville Railroad, which operated between Richmond, Virginia, and Greensborough, North Carolina. This was the beginning of the Piedmont Air Line Route, which would eventually run from "Washington and Richmond to Atlanta, Birmingham and the South."

The Piedmont Air Line Route was not the name of a railroad; rather, it was a marketing name for a route that ran on several railroads (in Georgia,

this would include the Atlanta & Richmond Air Line Railway and its successor, the Atlanta & Charlotte Air Line Railway). Other routes of the time included the West Point Route and the Kennesaw Route.

In 1879, Clyde linked the Richmond, York River & Chesapeake Railroad (formerly the Richmond & York River Railroad) with the Richmond & Danville Railroad in Richmond.

It was Clyde who formed the infamous Richmond & West Point Terminal Railway and Warehouse Company (Richmond Terminal Company) in 1880, although he was dead before all of the late nineteenth-century financial shenanigans occurred. The Richmond Terminal Company was formed as a holding company for the Richmond & Danville Railroad to allow non-connecting railroads to be consolidated (an illegal practice for a railroad in Virginia at the time, although not for a holding company). Clyde's son, William Clyde, was appointed president of the Richmond Terminal Company.

From 1877 on, a series of acquisitions was made by Clyde to expand the Piedmont Air Line:

- 1877: Atlanta & Charlotte Air Line Railway (bought from receivership);
- 1878: Charlotte, Columbia & Augusta Railroad;
- 1878: Spartanburg, Union & Columbia Railroad;
- 1881: Atlantic, Tennessee & Ohio Railroad;
- 1881: Asheville & Spartanburg Railroad;
- 1881: Northeastern Railroad of Georgia;
- 1881: Virginia Midland Railway;
- 1881: Atlanta & Charlotte Air Line Railway (leased to Richmond & Danville in perpetuity);
- 1881: Purchase of all the stock of the Roswell Railroad and the Elberton Air Line Railroad (feeder lines to the Atlanta & Charlotte Air Line Railway). They operated as wholly owned subsidiaries of the Richmond Terminal Company;
- 1881: Formed the Georgia Pacific Railroad and appointed former Confederate general John Gordon as president. The railroad would operate from Atlanta to Birmingham and points west (the name may indicate that Clyde had thoughts of a transcontinental railroad line, but it never came to fruition).

Clyde died in January 1885, but the acquisitions continued even after his death:

- 1886: Washington, Ohio & Western Railroad;
- 1886: Western North Carolina Railroad;
- 1889: Columbia & Greenville Railroad.

The Piedmont Air Line Route was absorbed by the Southern Railway in 1894 but continued to operate under that name for a number of years.

LEMUEL GRANT

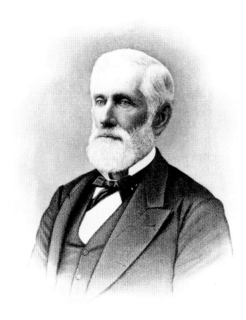

Lemuel Grant. *From* Atlanta and Its Builders *(Thomas H. Martin, Century Memorial Publishing Company, 1902).*

Lemuel Grant, born on August 11, 1817, in Frankfort, Maine, holds the distinction of having worked for or on all five of the biggest pre–Civil War railroads in Georgia. In the 1840s, he began working for Fannin, Grant & Company, which helped build the Georgia Railroad; the Central Railroad; the Macon & Western Railroad; the Western & Atlantic Railroad; and the Atlanta & West Point Railroad. In 1845, he served as the chief engineer of the Georgia Railroad, and in March 1849, he began location surveys for the northern terminus (East Point) of the Atlanta & West Point.

In 1857, the Southern Pacific Railroad contracted with Fannin, Grant & Company to build a line from Marshall, Texas, to the West Coast. The next year, Lemuel Grant was named president of Southern Pacific.

Grant is perhaps most famous for his work building the fortifications for Atlanta, which formed a circle one mile out from the center of town. He began this work in August 1863, and it was in place during Sherman's

Atlanta Campaign. Ironically, Grant's defenses were never really put to the test, as Sherman adopted a strategy of cutting off railroad access to Atlanta rather than attacking it head on. There is almost nothing left of Grant's nineteen redoubts and miles of fortifications except Fort Walker in the southeast corner of Grant Park.

In 1865, Grant served as superintendent of the Western & Atlantic and Atlanta & West Point Railroads, as they were returned to Georgia control by the United States Military Railroad (USMRR).

In 1873, he formed the Bank of the State of Georgia. In 1882, he donated one hundred acres that would eventually become Grant Park, home of the Atlanta Zoo and, until recently, the Atlanta Cyclorama. In 1977, his great-grandson Bryan M. "Bitsy" Grant Jr. was inducted into the Tennis Hall of Fame.

Lemuel Grant died on January 11, 1893, in Atlanta, Georgia, and was buried at Westview Cemetery. He had established the cemetery in 1884.

John H. Inman

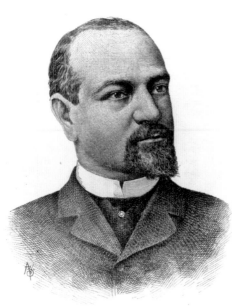

John Inman was one of the great forces in the development of manufacturing, mining and railroading interests in the South in the late part of the nineteenth century. Although born in Tennessee (on October 23, 1844, in Jefferson County), he had ties to Atlanta—at age fifteen, John Inman worked as a clerk in a bank owned by his uncle in Georgia. Inman's father eventually moved to Atlanta, giving Inman more ties to the Peach State.

John Hamilton Inman. *Courtesy Library of Congress.*

In 1861, he enlisted in the Confederate army and eventually survived the war. In September 1865, he went to New York with $100 in his pocket to find fame and fortune; he soon found employment at a cotton house. In 1868, he became a full partner at the business.

In 1871, Inman formed the cotton house Inman, Swann and Company with his partners from the former business. Through this company, John Inman became a very rich man.

Inman went on to invest $5 million in the Tennessee Coal, Iron and Railroad Company (later absorbed by U.S. Steel), which had iron and coal interests in Birmingham and Bessemer City, Alabama. It is said that he induced another $100 million in the development of the South from friends and associates. He was a key figure in the development of the Southern Iron Company.

In 1876, according to the Southern Railway, *Inman, South Carolina* was named for John H. Inman. Other stories say that it was named for a surveyor named John Inman.

In 1883, Inman became a director of a number of southern railroads, including East Tennessee, Virginia & Georgia Railroad, the Richmond & Danville Railroad, the Louisville & Nashville Railroad and the Nashville, Chattanooga & St. Louis Railway. By 1886, Inman was investing in the Richmond Terminal Company and soon became a director.

In 1887, Inman authorized farther westward expansion of the Georgia Pacific Railroad, extending it to Columbus, Mississippi (on the eastern side of the state). Eventually, it would be completed all the way to the Mississippi River.

On May 31, 1888, Inman was appointed president of the Richmond Terminal Company. This tied his fortunes to those of the RTC, and in 1893, he was seriously affected by the financial panic and the scandals affecting the Richmond Terminal Company.

In 1891, he was appointed New York City's rapid transit commissioner. He held this post until his death on November 5, 1896, in Berkshire, Massachusetts (or, according to other sources, in a sanitarium in New Canaan, Connecticut).

In 1957, Inman Yard in Atlanta was named by the Southern Railway.

Stephen Harriman Long

The Western and Atlantic railroad, when viewed in its relations to the natural and artificial channels of trade and intercourse above considered, is to be regarded as the main connecting link of a chain or system of internal improvements, more splendid and imposing than any other that has ever been devised in this or any other country. In contemplating the widely extended and incalculable benefits, in a civil or military, moral or commercial, and even religious point of view, that must undoubtedly result from its consummation, we are overwhelmed with the flood of magnificent results that breaks upon us.

—Stephen Harriman Long, 1837 W&A Survey, *Southern Museum of Civil War and Locomotive History*

Stephen Harriman Long, born in Hopkinton, New Hampshire, on December 30, 1784, was a man of many talents and perhaps can even be referred

to as a Renaissance man. He was a soldier, engineer, explorer, surveyor, author and designer of steamboats and locomotives.

Long graduated from Dartmouth College in 1812, and two years later, he was appointed lieutenant of engineers in the U.S. Army Corps of Engineers. In 1816, he was assigned to the Southern Division as a topographical engineer

"Major Stephen H. Long on the Rocky Mountain Expedition," circa 1835. *National Park Service.*

under Major General Andrew Jackson. In 1817, he began his career as an explorer, which included many highlights:

- 1817: Led a military expedition to the confluence of the Mississippi and Minnesota Rivers;
- 1819: Led the scientific portion of the Yellowstone Expedition to explore the Missouri River;
- 1820: Led an expedition to explore the Louisiana Purchase, including the search for the source of the Arkansas, Platte and Red Rivers;
- 1823: Led a military expedition to the border of the United States and Canada. After the Canada expedition, Long turned his attention to locomotives and steamboats and also worked as a surveyor for several railroads;
- 1826: Received a patent for a steam locomotive;
- 1827–30: Surveyed the Baltimore & Ohio Railroad;
- 1832: Formed the American Steam Carriage Company with several partners (the company was out of business within two years);
- June/November 1836: Surveyed the Belfast & Quebec Railroad.

It is at this point that Long enters into the Georgia railroad story. On May 12, 1837, Long signed a contract with the State of Georgia to survey the Western & Atlantic Railroad, which would run from Terminus (Atlanta) to Chattanooga.

For its time, the W&A was a serious surveying and construction proposition. The route was very crooked, with ten thousand degrees of curvatures in 138 miles—enough to make twenty-eight complete circles! W&A superintendent John W. Lewis stated in his 1860 annual report that the W&A was "the crookedest road under the sun." Long's solutions to engineering curves became standard in the railroad industry for many years after.

There were also a number of natural obstacles on the W&A. Along with crossing several rivers—including the Chattahoochee, the Etowah and the Oostanaula—the W&A also had to tunnel through the Chetoogeta Mountain (Tunnel Hill) at the northern end of the line.

The finished product, which opened in 1850, followed Long's original survey closely. Alas, Long wasn't there to see the completion, as he had stepped down as chief engineer on November 3, 1840, after complaints about construction delays.

For the next twenty years prior to the Civil War, Long turned his attention to steamboats and waterways. In 1840–46, he was in charge of dredging operations on various rivers, including the Mississippi, Missouri, Ohio and Arkansas. He launched six steamboats under the auspices of the Quartermasters Corps in the fall of 1847. In 1850–56, he became "Superintendent of the Western Waters," and in 1860, Long published *Voyage in a Six-Oared Skiff to the Falls of St. Anthony*, about his 1817 expedition.

In 1863, Long was promoted to colonel in the Union army, but he didn't have very long to enjoy his new rank. He died on September 4, 1864, in Alton, Illinois.

J.P. Morgan

J.P. Morgan was a banker, a financier, a philanthropist and a turn-around specialist for sick businesses. He saved the United States from financial ruin, twice.

He was born in Hartford, Connecticut, on April 17, 1837. After a youthful bout with rheumatic fever in 1852 (it took him a year to recover), Morgan was ready to take on the world. In his early banking career, he worked for several companies that had financial ties to his father, Junius Spencer Morgan: Peabody, Morgan & Company (London) in 1857; Duncan, Sherman & Company (New York) in 1858; J. Pierpont Morgan & Company in 1860–64; Dabney, Morgan and Company in 1864–72; and Drexel, Morgan & Company in New York City in 1871 (in 1895, this company would become J.P. Morgan & Company).

It wasn't until after the death of his father in 1890 that John Pierpont Morgan would become an international superstar. He had a number of accomplishments as a financier. In 1892, he merged Edison General Electric and Thomson-Houston Electric Company to form General Electric. He combined the Memphis & Charleston Railroad, the Richmond & Danville system and the East Tennessee, Virginia & Georgia Railroad to form the Southern Railway in 1894. In 1901, he merged Federal Steel Company with the Carnegie Steel Company to form the United States Steel Corporation, the world's first billion-dollar company (capitalization at $1.4 billion). In 1895, Morgan helped save the United States Treasury by selling it 3.5 million ounces of gold for a thirty-year bond, and in 1907, during the Panic of 1907, Morgan, working with U.S. Treasury secretary George B.

John P. Morgan *(facing camera)*, 1917. *Courtesy Library of Congress.*

Cortelyou, arranged for the heads of the big banks to meet and avert a financial catastrophe.

Although not primarily a railroad man, Morgan was directly or indirectly responsible for the fortunes of many railroads and railroad organizations in his time:

- Atchison, Topeka & Santa Fe Railway
- Atlantic Coast Line
- Central of Georgia Railroad
- Chesapeake & Ohio Railroad
- Chicago & Western Indiana Railroad
- Chicago, Burlington & Quincy
- Chicago Great Western Railway
- Chicago, Indianapolis & Louisville Railroad
- Elgin, Joliet & Eastern Railway
- Erie Railroad
- Florida East Coast Railway
- Hocking Valley Railway
- Lehigh Valley Railroad
- Louisville & Nashville Railroad
- New York Central System
- New York, New Haven & Hartford Railroad
- New York, Ontario & Western Railway
- Northern Pacific Railway
- Pennsylvania Railroad
- Pere Marquette Railroad
- Reading Railroad
- Southern Railway
- St. Louis & San Francisco Railroad
- Terminal Railroad Association of St. Louis

By 1893, the Richmond Terminal Company (owner of the Central Railroad in Georgia) had run into significant financial problems. J.P. Morgan conducted a financial reorganization of RTC, and the Southern Railway was born. It would encompass about 4,800 miles of track.

In October 1894, the first shareholders meeting of the Southern Railway was held, and a board (with three Morgan appointees included) was elected, with Samuel Spencer as president. Spencer would go on to build new shops in Atlanta, Georgia.

On March 31, 1913, Morgan died in Rome, Italy, in his sleep. Upon the return of his body to the United States, the New York Stock Market closed for two hours as his body passed through the city.

HENRY BRADLEY PLANT

Perhaps *the* exemplar of a southern railroading tycoon was the almost forgotten Henry Bradley Plant. At one time, in the second half of the nineteenth century, he controlled most of the railroads in southern Georgia and Florida.

He was born on October 27, 1819, in Branford, Connecticut. In 1843, he married Ellen Blackstone (died in 1861). His marriage to her is what eventually led him south.

From 1844 to 1853, Plant worked for the Adams Express Company in New Haven, Connecticut. He soon became proficient in all aspects of express package handling, and in 1853, he moved south because of his wife's declining health. From 1853 to 1860, he served as general superintendent of the southern division of the Adams Express Company.

In 1861, the Confederacy seized all of the assets of the Adams Express Company, and Plant worked out a deal whereby he took over those assets. In 1861, he became president and owner of the new Southern Express Company. He didn't get to spend much time in that role, however, because Jefferson Davis appointed him agent for the Confederate government for collecting tariffs and transferring funds. He traveled extensively for the rest of the war.

After the war, in 1867, he was back in the express package business, as he became president of the Texas Express Company.

In 1873, he married Margaret Josephine Loughman. His marriage to her becomes significant when we reach the end of the Henry Bradley Plant saga. It wasn't until 1879, however, that "Henry Plant, railroad baron" emerged. In that year, he and some other investors purchased the Atlantic & Gulf Railroad of Georgia at a foreclosure sale. He soon became president of the newly named Savannah, Florida & Western Railroad.

Plant quickly began expanding his railroad empire, sometimes through acquisitions and sometimes through constructing new branch lines. Unlike most other railroad entrepreneurs of the time, he paid for his acquisitions from current operating funds as opposed to taking on a large debt load. His expansion projects were many:

- 1880: Purchased the Savannah & Charleston Railroad at a foreclosure sale;
- 1881: SF&W built a seventy-five-mile line from Waycross, Georgia, to Jacksonville, Florida, via Folkston, Georgia;
- 1882: Created the Plant Investment Company, which Bradley used to manage his railroad properties;
- 1882: Expanded the Savannah, Florida & Western Railroad from Bainbridge, Georgia, to Chattahoochee, Florida, where it linked up with the L&N-controlled Pensacola & Atlantic Railroad;
- 1884: Expanded the Savannah, Florida & Western Railroad from Live Oak, Florida, to Gainesville, Florida;
- 1887: Purchased the Brunswick & Western Railroad.

Not content to be restricted to land-based transportation methods, in 1886 Plant formed a steamship company (Plant Steamship Line) that operated from Mobile to Tampa and from Tampa to Havana.

In the late 1880s, Plant decided that one way to attract passengers to Florida as tourists was to build hotels. From 1887 to 1898, he built hotels in Sanford, Punta Gorda, Port Tampa, Kissimmee, Fort Myers, Clearwater and others. The Tampa Hotel, which cost $3 million to construct, was used as a staging area during the Spanish-American War.

By 1895, Plant had become so well known and recognized as a successful southern railroader that a "Henry Plant Day" was held at the Cotton States and International Exhibition in Atlanta, Georgia. By the late 1890s, cotton had become an important haulage item on all Georgia railroads as northern-owned cotton mill companies began building huge mills in the South, where labor was cheaper (in Georgia, there were no child labor laws).

Plant died on June 23, 1899, in New York City. His Plant System operated 1,500 miles of track in Georgia and Florida in 1900. Although Plant had attempted to take steps to ensure that his empire would stay intact, shortly after he died, his second wife and one of his sons sold most of the Plant System to the Atlantic Coast Line.

As for the Express business, in 1918, the Southern Express Company and the Adams Express Company merged as the American Express Company. In 1929, the American Express Company became the Railway Express Company.

JOHN EDGAR THOMSON

John Edgar Thomson, born on February 10, 1808, in Springfield Township, Delaware County, Pennsylvania, served as the chief engineer of two great railroads. One of them would become the largest corporation in the world.

Thomson started his railroad career in 1827 when he worked on a survey crew for the Philadelphia & Columbia Railroad. By 1830, he had been appointed head of the engineering division of the Camden & Amboy Railroad. In 1832, Thomson conducted a personal evaluation of British railroads, adding their techniques to his own already impressive railroad engineering knowledge.

In 1834, he was appointed chief engineer of the Georgia Railroad, a post that paid him $4,000 by 1837. In charge of surveying, route selection and all aspects of construction, by 1845 Thomson had completed the Georgia Railroad from Augusta to Marthasville (Atlanta). A town thirty-eight miles west of Augusta changed its name to Thomson, Georgia, in honor of the chief engineer of the line. Legend says that it was John Edgar Thomson who decided to rename Marthasville to Atlanta, perhaps because "Marthasville" was too long for railroad paperwork purposes.

With his job as chief engineer of the Georgia Railroad complete, in 1847 Thomson was appointed chief engineer of the Pennsylvania Railroad. In 1852, he was appointed president of the Pennsylvania Railroad.

During his tenure as president, the Pennsylvania Railroad would become the largest corporation in the world and boast six thousand miles of track. Thomson was known for his conservative expansion policies and low-risk financial decisions. His accomplishments regarding the physical plant of the railroad include the double-tracking of the Philadelphia/Pittsburgh mainline, the bridging of the Susquehanna River, the design and construction (with Herman Haupt) of the Horseshoe Curve and the conversion of PRR locomotives from wood to coal.

In May 27, 1874, Thomson died of a heart attack in Philadelphia, Pennsylvania. A plaque in his honor has pride of place at Thirtieth Street Station in Philadelphia, Pennsylvania.

COLONEL WILLIAM MORRILL WADLEY

Colonel William Morrill Wadley, almost unknown today, was born on November 12, 1813, in Brentwood, New Hampshire. He developed skills

as a blacksmith early on. In 1833, he participated in the construction of Fort Pulaski. He soon turned to building railroads, though, and worked on a number of southern railroads prior to the Civil War.

In 1844, he built a railroad bridge over the Oconee River for the Central Railroad. From 1844 to 1849, he served as road master and then superintendent of the construction of the great roundhouse in Savannah (still standing). In 1849, he was superintendent of construction for Central Railroad. On February 2, 1852, he became construction superintendent of the Western & Atlantic Railroad. In 1853, he was named superintendent of the Central Railroad and, around 1855, superintendent of the New Orleans, Jackson & Great Northern Railroad. In 1859–60, he worked as superintendent of the building of the Southern Railroad in Mississippi. In 1860–61, he was superintendent of the Vicksburg, Shreveport & Texas Railroad.

He was commissioned in 1862 as a colonel in the Confederate army in the adjutant general's department. He was quickly appointed supervisor of railroads. His authority was defined by the following, according to the *Official Records*:

General Orders No. 98
Adjt. and Insp. General's Office
Richmond, December 3, 1862

Col. William M. Wadley, assistant adjutant-general, is hereby specially assigned to take supervision and control of the transportation for the Government on all the railroads in the Confederate States.

1. He is empowered to make contracts for transportation with said railroads, or any of them, and such negotiations and arrangements with them as may be requisite or proper to secure efficiency, harmony, and co-operation on the part of said railroads, or any proper number of them, in carrying on the transportation of the Government.

2. He will take direction of all agents or employees engaged by the Government in connection with railroad transportation; will retain, engage, or dismiss such as may be requisite, and take charge of and employ all engines, machinery, tools, or other property of the Government owned or used for railroad transportation; and may exchange, sell, or loan such machinery with or to any railroad company to facilitate the work of transportation; and may generally assist and co-operate with the railroads in effecting the work of transportation.

3. The better to accomplish such ends, he may require co-operation and assistance to such an extent as can be reasonably granted by the Quartermaster and Commissary Bureaus; and may apply for details from the Army of such artisans, mechanics, and workmen as may be necessary to facilitate the due accomplishment of his duties.

4. He will report, through the Adjutant and Inspector General, to the Secretary of War.

By order
S. COOPER
Adjutant and Inspector General

In January 1866, he became president of the Central Railroad (a position he held until 1882). The Central Railroad was in bad shape as a result of the war, but by 1867, it was again making a profit from its freight operations. Wadley then embarked on a significant expansion program:

- 1869: The Central leased the Southwestern Railroad, which ran from Macon to Albany.
- 1870: The Central purchased a controlling interest in the Mobile & Girard Railroad, giving the Central access to Alabama via Columbus.
- 1872: Through a court case, the Central assumed legal control of the Macon & Western Railroad, including the Savannah, Griffin & North Alabama Railroad, which ran from Griffin to Carrollton. By 1872, the Central Railroad was controlling 723 miles of track in Georgia and Alabama.
- 1873: The Central completed the building of new port facilities in Savannah and went into the steamship business (via purchase of the Savannah Steamship Line).
- 1874: The Central created the Ocean Steamship Company out of the Savannah Steamship Line; Wadley, of course, was made president. The Ocean Steamship Company operated until World War II.
- 1875: The Central and Georgia Railroads purchased the Western Railroad of Alabama (part of the West Point Route). At this point, the Western Railroad of Alabama was a 122-mile-long line running from Selma to West Point, Georgia.
- 1879: The Central merged with the Southwestern Railroad.

The next part of the Wadley/Central saga deserves special attention. In 1881, Wadley tried to interest the board of the Central Railroad in leasing the Georgia Railroad, which would significantly expand the Central Railroad empire, as well as remove a potential competitor (although the Georgia Railroad would never achieve its pre–Civil War importance). The board refused Wadley's request, partially because it was worried about an anti-monopoly clause in the Georgia constitution that forbade large railroads from acquiring one another. The board probably assumed that the matter would be dropped.

Wadley felt so strongly about the importance of leasing the Georgia Railroad that he personally (along with financial backing from the L&N Railroad) leased the entire Georgia Railroad in May 1881, including the Western Railroad of Alabama and the Atlanta & West Point Railroad. This lease did not include the banking operations of the Georgia Railroad and Banking Company.

Wadley was quite aware that he could not personally meet the terms of the lease (8 percent of gross profits yearly or $600,000, whichever was higher). Since he knew that he couldn't handle the lease himself, on May 18, 1881, Colonel Wadley assigned 50 percent of the Georgia Railroad lease to the L&N Railroad, a dreaded competitor of the Central Railroad. Seeing the potential threat to their business if the L&N were to control the Georgia Railroad, on June 1, 1881, the directors of the Central Railroad bought out Wadley's 50 percent of the Georgia Railroad lease.

While all of this was happening, the Central Railroad acquired controlling interest in the Port Royal & Augusta Railroad in June 1881. This gave the Central access to another Atlantic port (in addition to Savannah).

Wadley is notable not just because of his expansion of the Central Railroad but also because he was a bit of a visionary. He was one of the first people to think in terms of a railroad *system* rather than railroad lines. By the end of the nineteenth century, railroad systems were all the rage, and Colonel Wadley is one of those who deserves the credit.

On August 10, 1882, Colonel Wadley died in New York City, and E. Porter Alexander was appointed president of the Central Railroad. On June 18, 1885, a bronze statue dedicated to Wadley was erected in Macon by "the employees of the Rail Road and Steamship Companies of which he was the head."

JOHN SKELTON WILLIAMS

John Skelton Williams is probably most well known for serving as United States comptroller of the currency (1914–21) and helping to establish the Federal Reserve system. But for our purposes here, he had another important role: he created the Seaboard Air Line Railway.

Williams was born in Powhatan County, Virginia, on July 6, 1865. By age eighteen, he was working in the investment office of his father, John Langbourne Williams.

In May 1895, the Savannah, Americus & Montgomery Railway was sold under foreclosure to John L. Williams and Sons and other financiers and renamed the Georgia & Alabama Railway. John Skelton Williams (one of the aforementioned sons) was named president.

In 1896, Williams began expanding the Georgia & Alabama by purchasing the Columbus Southern Railway (Columbus to Albany). In the same year, he began building track to Savannah and purchased land in that city for dock facilities. To aid with the latter, he created the Georgia and Alabama Terminal Company. This was a direct competitive assault on the Central Railroad.

"John Skelton Williams at desk," circa 1913. *Courtesy Library of Congress.*

In 1897, Williams extended the Abbeville & Waycross Railroad nine miles to Ocilla, Georgia. Two years later, in February 1899, the Georgia & Alabama Railway and Seaboard Air Line Railway and the 944-mile Florida Central & Peninsular Railroad agreed to merge, keeping the name Seaboard Air Line Railway.

The three railroads were connected after track was built from Cheraw, South Carolina, to Cayce, South Carolina. The SAL now reached from Richmond to Tampa. From 1900 to 1903, Williams served as the president of the Seaboard Air Line Railway (he also served as chairman of the American Bankers Association in 1901).

In 1903–4, Williams was forced out of the Seaboard Air Line Railway presidency by Thomas Fortune Ryan and other financiers in New York City. He never regained control of the vast railroad that he had created. His later positions included assistant secretary of the U.S. Treasury (March 1913), United States comptroller of the currency (1914–21), director of finance and purchases of the United States Railroad Administration (1917–19), member of the Central Committee (and later treasurer) of the American Red Cross (October 1918) and president of the Richmond Trust Company (1924).

He died on November 4, 1926, in Richmond, Virginia.

Chapter 2

PRE–CIVIL WAR RAILROADS
IN GEORGIA

P re–Civil War railroads in Georgia are indicated in the following table. I've included only railroads that actually laid track before the Civil War. The railroads indicated in italics were integral to Sherman's

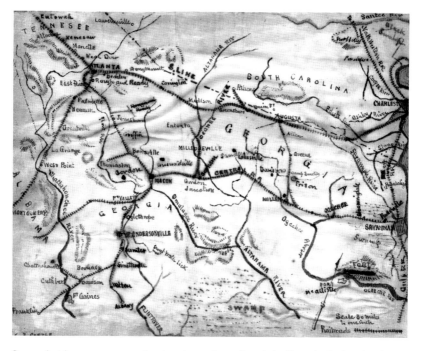

Somewhat inaccurate map showing the major railroads in Georgia during the Civil War. *Courtesy Library of Congress.*

strategy during the Atlanta Campaign and the March to the Sea. We'll take a look at them first. We'll also take a look at some of the larger (more than one hundred miles of track and/or strategic importance) post–Civil War railroads in Georgia later in this chapter.

Railroad	Date Created	Notes
Central Railroad & Canal Company	1833	beginning of the Central Railroad
Monroe Railroad Company	1833	predecessor of the Macon & Western (December 1845)
Georgia Railroad	1833	
Western & Atlantic	December 1836	state-owned
Southwestern Railroad	December 1845 (chartered); construction began in 1848	later absorbed into the Central Railroad
Milledgeville & Gordon Railroad	1847	later absorbed into the Central Railroad
Atlanta & LaGrange	1849 (construction begins)	predecessor of the Atlanta & West Point Railroad
Rome Railroad	December 1849 (line completed)	feeder line to W&A
Washington Railroad	1850	later absorbed by the Georgia Railroad
Eatonton Branch Railroad	1852	Eatonton to Milledgeville
Augusta & Savannah Railroad	1854 (first track laid)	later absorbed into the Central Railroad

Opposite: Ruins of a roundhouse in Atlanta, 1866. *Courtesy Library of Congress.*

ATLANTA & WEST POINT

Construction on what would become the Atlanta & West Point Railroad (originally the Atlanta & LaGrange Railroad, chartered in 1847) began in the fall of 1849. Since the planned southwestern terminus was to be West Point, Georgia, the northeastern terminus was named East Point, as it is still named today. Financial backing came from John King and others at Georgia Railroad. Lemuel Grant was appointed chief engineer and John King president.

In early 1854, the railroad reached LaGrange, and in May 1854, it reached West Point and linked up with the Montgomery & West Point Railroad. However, the A&WP Railroad and the M&WP Railroad had different gauges—the latter using 4 feet, 8.5 inches and the former using 5 feet (oops).

On December 22, 1857, the Atlanta & LaGrange Railroad officially changed its name to the Atlanta & West Point Railroad.

Civil War

The A&WP Railroad sustained damage during McCook's raid on July 28, 1864, in both Palmetto and Fairburn. At about 6:00 p.m. on that day, McCook

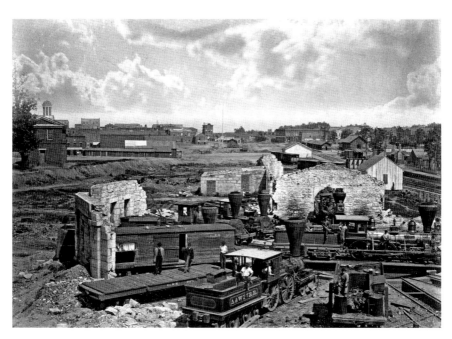

burned the depot at Palmetto and destroyed "two and one-half miles of the Atlanta and West Point Railroad and telegraph wire." Also, "a few box cars containing a quantity of salt, bacon, flour, and other commissary stores" were destroyed. The "glare of the light" could be seen in Newnan to the south, according to the *Official Records*:

> *Last Thursday, the 28th, about dark, scouts brought in word that the enemy was crossing the river in large force. There was little heed paid to the report, as we had heard so many lately. About 9 o'clock the whole sky was illuminated by a glare of light, in the direction of Palmetto, a small town on the railroad. We knew then what we had to expect, and got ready as usual; whiskey, and every thing of any consequence, was sent off; the men who were able taking to the woods.*

Like the Macon & Western Railroad, the A&WP Railroad also sustained damage during Kilpatrick's raid in August 1864. See the M&W Railroad section for more details.

Postwar

On August 7, 1866, the Montgomery & West Point Railroad track gauge was changed to 5 feet so that passengers could now travel directly from Montgomery to Atlanta without changing trains in West Point. Of course, in 1881, 4 feet, 8.5 inches became the national standard, so both railroads had to make the change at that time.

From 1875 to 1878, Brigadier General E. Porter Alexander served as president and general manager of Western Railroad of Alabama, which linked up with the A&WP Railroad. This included the old Montgomery & West Point Railroad and extended the western trackage to Selma.

Beginning in 1886, the A&WP and the Western Railway of Alabama operated under the name West Point Route. This was fairly advanced thinking for the time, as it was one of the first times that two or more railroads referred to the *route* of a train rather than to the individual railroads on which it ran. The Great Kennesaw Route would be another example from the same period, running on the Western & Atlantic and north.

In the late nineteenth and early twentieth centuries, the A&WP, the Western Railway of Alabama and the Georgia Railroad were controlled under a joint lease by the Central of Georgia Railroad and the Louisville

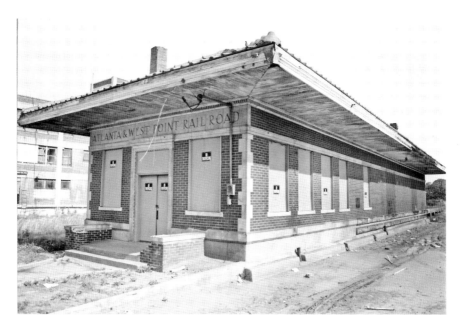

Atlanta & West Point Freight Depot (Ormewood Station), built circa 1930. It is now a restaurant. *Photo by Robert C. Jones.*

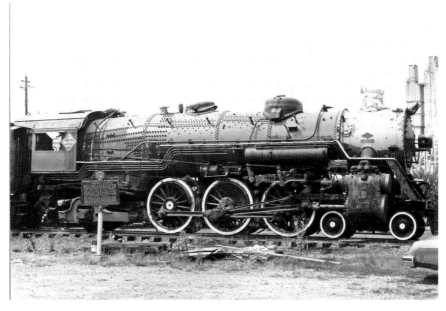

Number 290, a Pacific type 4-6-2 steam passenger engine, built March 1926. It's now located at the Southeastern Railway Museum. *Photo by Robert C. Jones.*

& Nashville Railroad. In 1898, the A&WP and the Western Railway of Alabama finally merged.

In 1902, the Atlantic Coast Line acquired a controlling interest in the L&N and thus controlled the Georgia Railroad, the A&WP and the Western Railway of Alabama. In 1944, the Central of Georgia Railway sold its interest in the A&WP to the ACL.

In 1967, the ACL merged with the Seaboard Air Line Railroad to form the Seaboard Coast Line Railroad (SCL), which included the old A&WP. On January 7, 1970, passenger service on the A&WP ended.

In the early 1970s, the SCL merged with the Louisville & Nashville Railroad and the Clinchfield Railroad and operated under the marketing title of the Family Lines System.

In 1986, the Atlanta & West Point name passed into history, as CSX Transportation was formed when the Seaboard Coast Line merged with the Chessie System.

In 1989, the heavy Pacific A&WP 290 was restored to running order and pulled excursions around Atlanta on the New Georgia Railroad. I was on one of these excursions during this period when I worked for Hewlett-Packard.

Central Railroad

The building of the Central Railroad began in early 1838 when twenty-six miles of track were laid from Savannah to Eden. Further milestones included May 1839, when track was completed to Millen (seventy-eight miles from Savannah); 1841, when the line was completed from Savannah to Tennille; October 1843, when track was completed to Macon (or, at least, the east side of the Ocmulgee River); and 1851, when a bridge over the Ocmulgee River into Macon was completed.

In 1849, William H. Wadley became supervisor of construction for the Central Railroad and remained in the position until 1852. He would return again in the future with a greater role.

Civil War

Sherman hit the Central Railroad hard and often during his March to the Sea, as the following excerpts from the *Official Records* show.

Central of Georgia railroad passenger station and train shed, Savannah, Georgia. *Courtesy Library of Congress.*

MACON

From Major General O.O. Howard:

> *General Kilpatrick waited at Clinton until the arrival of the head of the infantry column, at 12 m., when he moved out toward Macon on the left Macon road. He met the enemy's cavalry about four miles from Macon, drove them in, and charged their works, defended by infantry and artillery. The head of his column got inside the works, but could not hold them. He succeeded in reaching the railroad and destroyed about one mile of the track. The road was struck in two or three places by the cavalry, besides the above, and a train of cars burned.*

GRISWOLDVILLE

From Brigadier General Judson Kilpatrick, cavalry commander:

> *A detachment of Ninth Michigan Cavalry, Captain Ladd commanding, had already struck the railroad at Griswold Station, capturing a train of*

thirteen cars, loaded with engine driving wheels and springs for same. The station was destroyed; pistol, soap and candle factories burned.

Regarding the Central Railroad Company of Savannah on November 21, 1864:

Major-General McLaws:
…I received the following from Augusta, from our operator at Gordon, written yesterday:
The lumber train was captured at Griswoldville and burned today. Negroes all safe. Destroyed the machine shops and foundry and Georgia Chemical Works. Road burned at Griswoldville.

Very respectfully, your obedient servant,
R.R. Cuyler, President.

Tennille

From Brigadier General N.J. Jackson:

…my command marched to the Georgia Central Railroad at Tennille Station and destroyed six miles of track, the railroad depot, Government warehouses, and 324 bales of cotton.

Milledgeville

From Brigadier General A.S. Williams:

Large quantities of arms, ammunition, and accouterments were found and destroyed, as well as salt and other public property….The railroad depot, two arsenals, a powder magazine, and other public buildings and shops, were burned. The railroad track for five miles toward Gordon was destroyed.

Millen

From H.W. Slocum:

General Kilpatrick has returned to Louisville. He destroyed portions of the road between Millen and Augusta, and had some severe fighting with Wheeler.

Waynesboro

From Brigadier General Judson Kilpatrick:

> *Struck the railroad at Waynesborough…having destroyed the station and train of cars captured day previous, and partly burned the bridge over Brier Creek. Here I learned that our prisoners had been moved from Millen, Ga.; and, after destroying track sufficient to prevent transportation for a few days, deemed it prudent to retire our infantry in direction of Louisville, Ga.*

From Captain Jos. C. Audenried, U.S. Army:

> *…We burned the bridge, about 120 feet long, over Brier Creek, four miles north of Waynesborough, during Saturday night. Captured at Waynesborough a train of 8 box and 3 platform cars and a locomotive, all of which were burned, the cargo, hogs for Augusta, turned loose.*

Postwar

Although the Central Railroad had been almost totally destroyed by Sherman in 1864, by 1869 it was substantially functional again. Ownership of the Central Railroad would change hands several times over the next 125 years. In 1869, the Central Railroad leased the Southwestern Railroad, which headed south from Macon to Albany. This expanded the reach of the Central Railroad into southwest Georgia.

Expansion continued in the 1870s. In 1870, the Central Railroad purchased a controlling interest in the Mobile & Girard Railroad, giving the Central access to Alabama via Columbus. In 1872, through a court case, the Central Railroad assumed legal control of the Macon & Western Railroad, including the Savannah, Griffin & North Alabama Railroad, which ran from Griffin to Carrollton. By this point, the Central Railroad controlled 723 miles of right of way in Georgia and Alabama.

Not content to simply move freight on land, the Central Railroad in 1873 completed the building of new port facilities in Savannah and went into the steamship business via purchase of the Savannah Steamship Line. The next year, the Central Railroad created the Ocean Steamship Company out of the Savannah Steamship Line. It would operate until World War II.

This sort of vertical integration is out of favor today but served as the foundation for most of the large American industries in the latter part of the nineteenth century.

In 1875, the Central Railroad and Georgia Railroad purchased the Western Railroad of Alabama (part of the West Point Route). At this point, the Western Railroad of Alabama was a 122-mile-long line running from Selma to West Point, Georgia.

In 1879, the Central Railroad merged with the Southwestern Railroad, which it had been leasing since 1869.

In May 1881, Colonel William H. Wadley, president of the Central Railroad, did something remarkable: he personally (along with financial backing from the L&N Railroad) leased the entire Georgia Railroad, including the Western Railroad of Alabama and the A&WP. This lease did not include the banking operations of the Georgia Railroad and Banking Company. Wadley had tried for months to get the board of the Central Railroad to agree to lease the Georgia Railroad, but it had demurred. So, he made it happen himself.

Since he really couldn't afford the whole lease himself, Colonel Wadley on May 18, 1881, assigned 50 percent of the Georgia Railroad lease to Central Railroad competitor the Louisville & Nashville Railroad. Alarmed by the encroachment of the L&N, the directors of the Central Railroad (finally) bought out Wadley's 50 percent of the Georgia Railroad lease on June 1, 1881.

In the same month, the Central Railroad obtained controlling interest in the Port Royal & Augusta Railroad, giving the Central access to another Atlanta port (in addition to Savannah).

In August 1882, Colonel Wadley died, perhaps overwhelmed upon reflection that he had leased a whole major railroad himself using his personal finances. E. Porter Alexander was appointed president of the Central Railroad.

Dynastic forces were in play, though, and in December 1882, Alexander was ousted as president of the Central Railroad because of his expansionist policies and replaced with Wadley's son-in-law, William G. Raoul. Alexander would get his revenge, though—in December 1886, he would (again) be appointed president of the Central Railroad.

In 1888, the Richmond Terminal Company and the Georgia Company gained a controlling interest in the Central Railroad. Through shady stock transfers, this would eventually lead to the bankruptcy of the Central Railroad (a profitable railroad) just three years later.

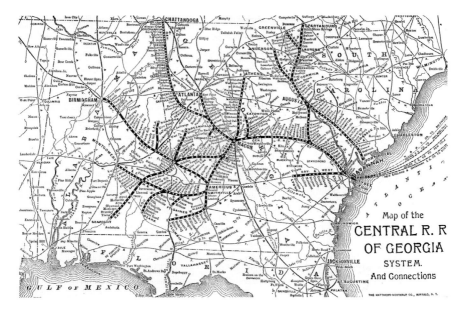

Central of Georgia route map, 1892.

In 1889, an agreement among the Central Railroad, the Savannah & Western Railroad and the Savannah, Americus & Montgomery Railroad extended trackage rights to each. Within six years, this agreement would let the nose of the Seaboard Air Line into the tent of the Central Railroad monopoly over the port of Savannah.

In 1890, President Alexander purchased the Chattanooga, Rome & Columbus Railroad for the Central Railroad. Combined with the Savannah, Griffin & North Alabama Railroad already owned by the Central Railroad, the Central now had a route from Savannah to Chattanooga (although not the most direct route possible). In June 1891, the Central Railroad was leased by the Georgia Pacific Railroad on behalf of the Richmond Terminal Company. This arrangement wouldn't last for long.

And then a little old lady brought down the Central Railroad (and, to an extent, the mighty Richmond Terminal Company). On March 3, 1892, Mrs. Rowena Clarke of Charleston, South Carolina, filed suit against the Richmond Terminal Company on behalf of her fifty shares of Central Railroad stock. She contended that the lease of the Central by the Georgia Pacific Railroad violated the Georgia Constitution. She also was suspicious about the stock deals that seemed to be swirling around the increasingly poverty-stricken Central Railroad.

On March 1892, Judge Emory Speer (U.S. Circuit Court in Macon) agreed with Mrs. Clarke and forced the Central Railroad into receivership. This released the Central Railroad from the clutches of the Richmond Terminal Company. On March 28, 1892, Hugh Comer, president of Bibb Manufacturing Company, was appointed receiver of the Central Railroad by the judge.

On January 22, 1893, the first Nancy Hanks passenger train was run between Atlanta and Savannah. Nancy Hanks was a popular race horse of the day. The train operated on an express schedule, only stopping at a few stations. It was a huge hit with passengers, but on August 12, 1893, the Nancy Hanks was discontinued because of high operating costs.

In 1895, the Central Railroad purchased the Macon & Northern Railroad, but something happened of greater strategic importance. The Seaboard Air Line Railroad bought the Savannah, Americus & Montgomery Railroad, along with its trackage rights on the Central Railroad into Savannah. And just like that, *poof!* Gone was the Savannah port monopoly of the Central Railroad.

On October 7, 1895, all assets of the Central Railroad were sold to the investment firm of Thomas & Ryan. Thomas & Ryan renamed it the Central of Georgia Railway; this meant that the Central was out of receivership. Hugh Comer was appointed president. Shortly afterward, on February 7, 1896, the Central Railroad bank ceased operations, leaving just the railroad in operation.

In 1899, arch-competitor Atlantic Coast Line purchased the 50 percent lease of the Georgia Railroad from the L&N and followed up the next year by purchasing the L&N itself. The Central of Georgia was now under competitive pressure from the Seaboard Air Line, the ACL and the L&N.

Twentieth and Twenty-First Centuries

In 1907, E.H. Harriman seized control of the Central of Georgia Railway. Harriman also owned the Union Pacific, Southern Pacific and Illinois Central. In 1909, Harriman sold his interest in the Central of Georgia Railway to the Illinois Central Railroad (which Harriman also controlled).

From 1932 to 1948, the Central of Georgia Railway operated in receivership, finding it difficult to compete against the aforementioned behemoths.

On July 17, 1947, the Nancy Hanks II, with its blue-and-gray cars, made its inaugural run between Savannah and Atlanta. The train would remain popular until the end of passenger service.

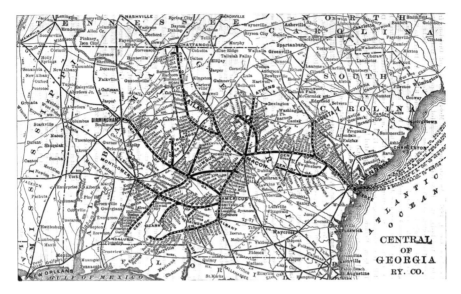

Poor's Central of Georgia Railway map, 1903.

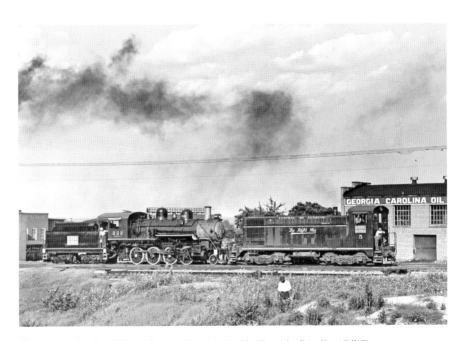

"Steam Engine No. 222 at Macon, Georgia beside Georgia Carolina Oil Company building, on July 21, 1947." *Courtesy of Southern Museum Archives & Library, from the collection of David W. Salter.*

Central of Georgia 4-8-4 steam locomotive built by Lima in 1942 takes on water, 1946. *Courtesy of Southern Museum Archives & Library, from the collection of David W. Salter.*

"Steam Engine No. 456 at Macon, Georgia Junction on March 5, 1949." *Courtesy of Southern Museum Archives & Library, from the collection of David W. Salter.*

On June 17, 1963, the St. Louis–San Francisco Railway sold its stock in the Central of Georgia Railway to the Southern Railway, a vast railroad with eight thousand miles of right of way created by J.P. Morgan in 1894. In 1971, the Southern Railway merged the Central of Georgia Railroad with the Savannah & Atlanta Railway and the Wrightsville & Tennille Railroad. It retained the name of Central of Georgia Railway with the newly merged railroads.

On April 30, 1971, the Nancy Hanks II made its last run. As a further sign that passenger service from private railroads was dead, the Atlanta Terminal Station was demolished in 1972. This action has been bemoaned by Georgia residents ever since, as it would be nice if there was a large station in downtown Atlanta that could handle Amtrak, MARTA Rapid Rail, bus service and perhaps even the new trolley service. But alas, little foresight went into the decision to tear down Atlanta Terminal Station.

You probably know the rest of the story from here. In 1980, the Norfolk & Western and Southern Railway formed the Norfolk Southern Corporation. The Central of Georgia Railway is no more.

Central of Georgia Railway, Bay Street Viaduct, Savannah, Georgia. *Courtesy Library of Congress.*

"Central of Georgia Railway, Savannah Repair Shops & Terminal Facilities." This is now the Georgia State Railroad Museum. *Courtesy Library of Congress.*

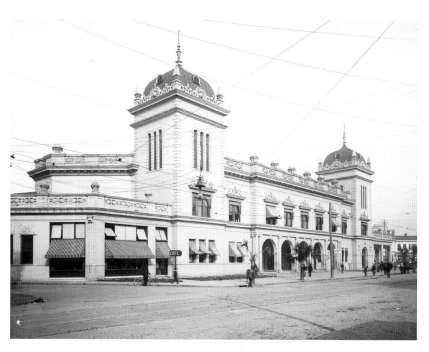

Union Station, Savannah, Georgia, circa 1904. *Courtesy Library of Congress.*

So, the Central of Georgia Railway was owned or leased by (at least) the following corporations or individuals in its history (beyond the original investors):

- Richmond Terminal Company (1888)
- Georgia Pacific Railroad (lease), on behalf of the Richmond Terminal Company (June 1891)
- Thomas & Ryan investment firm (October 7, 1895)
- E.H. Harriman (1907)
- Illinois Central Railroad (1909)
- Southern Railway (June 17, 1963)
- Norfolk Southern (1990)

Georgia Railroad and Banking Company

The Georgia Railroad was chartered in 1833 to provide a linkage with the South Carolina Canal and Railroad Company, which had run its tracks into Hamburg, South Carolina, just across the river from Augusta, Georgia. One of the smart decisions made early in the game was to name twenty-six-year-old John Edgar Thomson as chief engineer. Thomson would later go on to fame and glory as chief engineer and president of the Pennsylvania Railroad. The first president of the Georgia Railroad was James Camak, for whom a town is named in central Georgia.

Thomson began surveying in late 1834 and had started grading by 1835. Note that in both the case of the charter date and the beginning of construction, the Georgia Railroad preceded the Western & Atlantic.

Concurrently, on the business side, the directors of the Georgia Railroad received permission from the Georgia legislature to go into the banking business. The Georgia Railroad Bank was chartered on December 18, 1835. This proved to be a propitious choice, as there were times when the banking business was more profitable than the railroad business.

By the summer of 1837, the Georgia Railroad had proceeded thirty-eight miles west of Augusta, to a town that quickly changed its name to Thomson in honor of the chief engineer of the line.

By late 1841, the line was finished westward to Madison. In May 1841, the decision was made to continue the line all the way to Terminus, the southern end of the W&A Railroad. The line from Augusta to Terminus (now named

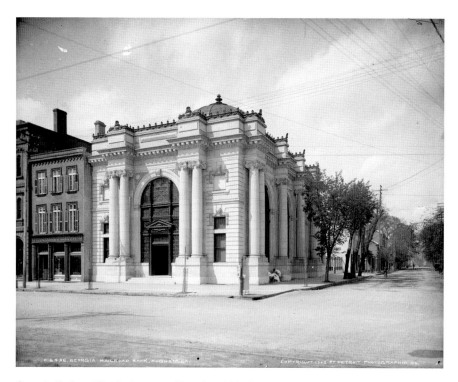

Georgia Railroad Bank, Augusta, Georgia, 1903. *Courtesy Library of Congress.*

Marthasville) was completed on September 14, 1845 (five years before the first train would run from Atlanta to Chattanooga). Legend says that it was John Edgar Thomson who decided to rename Marthasville to Atlanta, perhaps because "Marthasville" was too long for railroad paperwork purposes.

John Edgar Thomson left the Georgia Railroad in April 1847 to become chief engineer of the Pennsylvania Railroad. He became president of the PRR in 1852 and stayed in that position until 1874.

The Civil War

The Georgia Railroad, of course, was one of the transportation spokes on the wheel (with Atlanta at the center) that Sherman wanted to sever during the Atlanta Campaign. This was accomplished somewhat spectacularly by Union cavalry general Kenner Garrard when he destroyed two key bridges over the Yellow and Alcovy Rivers on the Georgia Railroad in a series of raids in July 21–24, 1864, as noted in the *Official Records*:

Results: Three road bridges and one railroad bridge (555 feet in length) over the Yellow River, and one road and one railroad bridge (250 feet in length) over the Ulafauhachee [Alcovy], were burned; six miles of railroad track between the rivers were well destroyed.

The depot and considerable quantity of Quartermasters' and commissary stores at Covington were burned. One train and locomotive captured at Conyers and burned; one train (platform) was burned at Covington, and a small train (baggage) at station near the Ulafauhachee, captured and burned....Citizens report a passenger train and a construction train, both with engines, cut off between Stone Mountain and Yellow River. Over 2,000 bales of cotton were burned.

A large new hospital at Covington, for the accommodation of 10,000 patients from this army and the Army of Virginia, composed of over thirty buildings, beside the offices just finished, were burned, together with a very large lot of fine carpenters' tools used in their erection.

Damage was also done to the Georgia Railroad during the March to the Sea. O.M. Poe, captain of engineers and chief engineer of the Military Division of the Mississippi, noted, "The Twentieth Corps destroyed the Augusta railroad from Social Circle to a point near Greensborough, the Fourteenth Corps destroying from Lithonia to Social Circle." And H.W. Slocum reported, "At Rutledge, Madison, Eatonton, Milledgeville, Davisborough, machine-shops, turn-tables, depots, water-tanks, and much other valuable property were destroyed. The quantity of cotton destroyed is estimated by my subordinate commanders at 17,000 bales. A very large number of cotton gins and presses were also destroyed."

Postwar

The Georgia Railroad recovered slowly after the Civil War. John King served as president of the Georgia Railroad and Banking Company from 1841 to 1878. In 1869, the Georgia Railroad Freight Depot was finished in Atlanta. It is now the oldest building in downtown Atlanta.

From 1878 to 1880, E. Porter Alexander, the famous Civil War artillery officer, served as president of Georgia Railroad and Banking Company. A top priority for Alexander was to gain access to an Atlantic port through the Port Royal & Augusta Railroad, but his attempts were blocked by the Central Railroad.

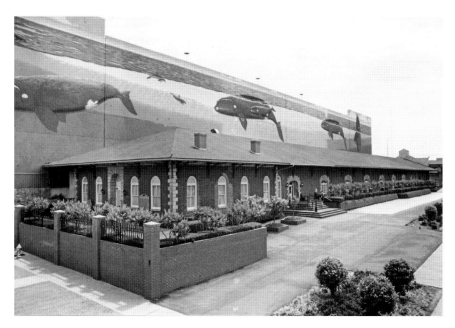

Georgia Railroad Freight Depot, built April 1869. *Photo by Robert C. Jones.*

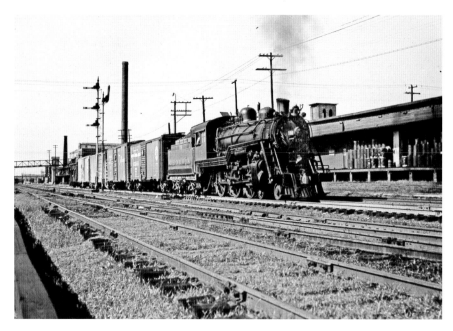

"Steam Engine No. 156 with freight at Macon Junction on May 9, 1948." *Courtesy of Southern Museum Archives & Library, from the collection of David W. Salter.*

In 1881, Colonel William M. Wadley, Central Railroad and Banking Company of Georgia president, leased the Georgia Railroad (including the A&WP and the Western Railway of Alabama), assigning half of the properties to the Central Railroad and half to the L&N. While the Georgia Railroad would continue to operate under its own name for another one hundred years, it would be under the control of other railroads.

While the Georgia Railroad was not as important in the late nineteenth century as it had been before the Civil War (partly because of competition with the Seaboard Air Line), investments in plant and equipment continued to be made. From 1890 to 1912, the Georgia Railroad purchased eighty-one new locomotives, mostly from Baldwin Locomotive Works of Philadelphia.

In 1892, the Central Railroad went bankrupt as a result of stock manipulation on the part of its owner, the Richmond Terminal Company. The Central Railroad lost its Georgia Railroad lease to the Atlantic Coast Line. So, if you're keeping score at home, the Georgia Railroad lease in 1896 was now shared 50-50 between the L&N and the Atlantic Coast Line.

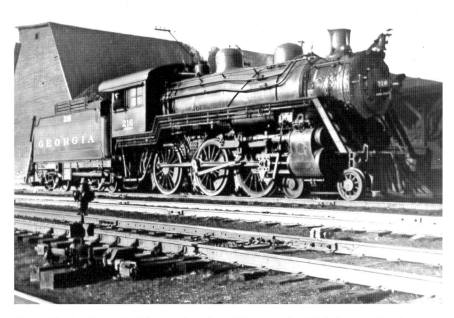

"Steam Engine No. 216 at Macon, Georgia on February 16, 1941." *Courtesy of Southern Museum Archives & Library, from the collection of David W. Salter.*

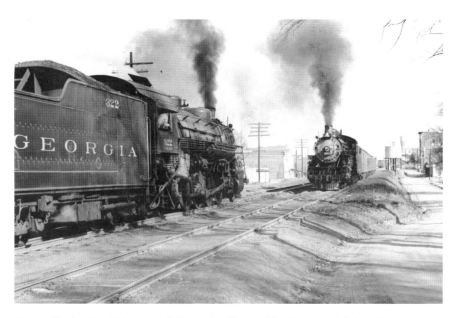

"Steam Engine No. 322, type 2-8-2, meeting Engine No. 253, type 4-6-2 at Thomson, Georgia, undated." *Courtesy of Southern Museum Archives & Library, from the collection of David W. Salter.*

In 1902, the Atlantic Coast Line acquired a controlling interest in the L&N and thus controlled 100 percent of the lease with the Georgia Railroad, as well as the Atlanta & West Point and the Western Railroad of Alabama.

Things were relatively quiet on the merger and acquisition front with the Georgia Railroad until 1967, when the ACL merged with the Seaboard Air Line Railroad to form the Seaboard Coast Line Railroad (SCL), forming a formidable network of track in Georgia.

During the mid-1970s, the Georgia Railroad had to deal with a special situation: Atlanta began building its rail lines as part of the Metropolitan Atlanta Rapid Transit Authority. And for a long stretch of the east line, MARTA and the Georgia Railroad tracks ran parallel and very close together. Pete Silcox was in charge of the project from the Georgia Railroad side of things:

When I was with the Georgia Railroad, around 1974–75, the thing called MARTA got started. And they built the east line parallel to the Georgia Railroad from downtown to Decatur. And it became my job to figure out what they were up to, and what they were going to do. And I ended up being in charge of that construction/relocation of the railroad for four years. It was a real tremendous job when I look back at it. I think at one point, I

had 25 people working for me. Because MARTA decided to build all seven miles in one big swoop, there were lots of contractors, lots of workers.

We moved the railroad south from the center line of our property about 25 or 30 feet to provide them enough room to build MARTA, all the way from Underground Atlanta to Avondale.

In the early 1970s, the SCL merged with the Louisville & Nashville Railroad and the Clinchfield Railroad and was then operated under the marketing nomenclature of the Family Lines System. The Georgia Railroad continued to be operated as a separate company, with the Family Lines holding the lease. This continued until 1983, when the Family Lines purchased the railroad part of the Georgia Railroad and Banking Company. At this point, the name Georgia Railroad faded into history.

In 1986, CSX Transportation was formed when Seaboard Coast Line merged with the Chessie System. The Georgia Railroad Bank merged with First Union (now Wells Fargo).

MACON & WESTERN (MACON TO ATLANTA)

In December 1833, the Monroe Railroad and Banking Company was chartered. By 1838, the road had been completed from Macon to Forsyth, Georgia, and by 1842, the Monroe Railroad and Banking Company had been completed to Griffin. Three years later, the Monroe Railroad went into foreclosure.

The Macon & Western came to be in December 1845, when a group of investors linked to the Georgia Railroad took over the foreclosed Monroe Railroad and Banking Company and renamed it the Macon & Western. The M&W never went anywhere to the West—its name reflected future hopes that were never realized.

On September 4, 1846, the Macon & Western was completed into Atlanta (East Point).

Civil War

The M&W was part of the four spokes of railroads that connected Atlanta to the outside world. Sherman made attempts to destroy the railroad via

cavalry in July and August 1864, as seen in this attack on Lovejoy's Station by Edward McCook in the *Official Records*:

> *He then pushed for the railroad, reaching it at Lovejoy's Station at the time appointed. He burned the depot, tore up a section of the railroad* [Macon & Western], *five miles of telegraph wire destroyed and McCook continued to work until forced to leave off to defend himself against an accumulating force of the enemy.*

Major R. Root, of the Eighth Iowa, described the damage done in Lovejoy's Station:

> *At Lovejoy's Station a detachment of the Eighth Iowa burned part of a train loaded with government stores, consisting of tobacco, lard, and arms. The tobacco was estimated by the citizens to be worth $120,000. The depot, water-tank, and road was destroyed for two miles by my command.*

However, McCook's raid, which was interrupted by the arrival of Joe Wheeler's cavalry, only interfered with Macon & Western operations for a few days. Another attempt to destroy the M&W Railroad link with Atlanta occurred via a cavalry raid by Judson Kilpatrick during the third week of August 1864, as described here by Sherman in the *Official Records*:

> *I suspended the execution of my orders for the time being and ordered General Kilpatrick to make up a well appointed force of about 5,000 cavalry, and to move from his camp about Sandtown during the night of the 18th to the West Point road and break it good near Fairburn, then to proceed across to the Macon road and tear it up thoroughly, but to avoid as far as possible the enemy's infantry, but to attack any cavalry he could find. I thought this cavalry would save the necessity of moving the main army across, and that in case of his success it would leave me in better position to take full advantage of the result. General Kilpatrick got off at the time appointed and broke the West Point road and afterward reached the Macon road at Jonesborough, where he whipped Ross' cavalry and got possession of the railroad, which he held for five hours, damaging it considerably, but a brigade of the enemy's infantry, which had been dispatched below Jonesborough in cars, was run back and disembarked, and with Jackson's rebel cavalry made it impossible for him to continue his work. He drew off to the east*

and made a circuit and struck the railroad about Lovejoy's Station, but was again threatened by the enemy, who moved on shorter lines, when he charged through their cavalry, taking many prisoners, of which he brought in 70, and captured a 4-gun battery, which he destroyed, except one gun, which he brought in. He estimated the damage done to the road as enough to interrupt its use for ten days, after which he returned by a circuit north and east, reaching Decatur on the 22d.

After an interview with General Kilpatrick I was satisfied that whatever damage he had done would not produce the result desired, and I renewed my orders for the movement of the whole army. This involved the necessity of raising the siege of Atlanta, taking the field with our main force and using it against the communications of Atlanta instead of against its intrenchments.

The final breaking of the link between Macon and Atlanta occurred with the Battle of Jonesboro, from August 31 to September 1, 1864.

In 1872, the M&W was bought by the Central Railroad, and the name Macon & Western faded into history. It became the Atlanta Division of the Central Railroad.

Western & Atlantic (Atlanta to Chattanooga)

On December 21, 1836, the Western & Atlantic Railroad was born. The Georgia legislature authorized the construction of a state-owned railroad from Chattanooga to Terminus, Georgia (now Atlanta). Companion legislation was passed by the Tennessee General Assembly on January 24, 1838, that allowed the railroad to be constructed into Tennessee. The W&A, one of the first railroads in Georgia, would prove to be an anomaly, as it was owned and operated by the State of Georgia for the first thirty-four years of its existence.

By 1838, more than five hundred men (including some Cherokee Indians) were at work on grading, roadbed and trestles. In 1840, the original engineer on the project (and the initial surveyor), S.H. Long, tendered his resignation after being criticized for slow progress. He would not be the last W&A engineer to resign for that reason.

In 1842, Charles Garnett was appointed the new chief engineer. More auspiciously, a wooden office was built in Terminus, cementing Atlanta as the future base of operations of the W&A railroad.

By 1845, the first twenty miles of track were in operation, allowing goods and passengers to travel from Terminus to the county seat of Cobb County, Marietta. On May 9, 1850, the first train traveled over the entire length of the W&A, from Atlanta to Chattanooga. The final cost of the railroad to the State of Georgia was $4,087,925.

The Civil War

The W&A Railroad is easily the most important of the five railroads in terms of strategic Civil War impact. It served as Sherman's supply line for his Atlanta Campaign.

Early in the war, in 1862, the W&A had forty-six locomotives in service, with ten in need of repair. One of those locomotives in service was the 4-4-0 American General, built by Rogers, Ketchum & Grosvenor in 1855. While sometimes assigned to freight duty, on the morning of April 12, 1862, the General was pulling an early morning passenger train from Atlanta to Chattanooga. It would not arrive on time in Chattanooga—it was hijacked along the way by Union raiders under James Andrews.

The Andrews Raid, as it was called, was part of a bigger strategy on the part of Union major general Ormsby Mitchel. Mitchel was in charge of defending Nashville, and he soon set his sights on Huntsville, Alabama, and Chattanooga, Tennessee. Working with a civilian spy, James J. Andrews, a plan was formulated whereby Andrews would lead a group of raiders deep into the heart of the Confederacy in Georgia to steal a train north of Atlanta and steam north to Chattanooga. The goal was to destroy as much of the railroad and communications infrastructure between Atlanta and Chattanooga as possible, thus cutting Chattanooga off from assistance from Atlanta during the planned Union attack there.

The plan was probably sound; however, the devil is in the execution. Most of the raiding party arrived one day late to Marietta, Georgia, the embarkation point for the raid. Thus, Andrews and his raiders were a day behind schedule. When the raid commenced on April 12, 1862, they were dogged by trains coming southbound from Chattanooga to Atlanta (as the Union offensive was already in full motion). Also, heavy rains made it impossible to burn the several wooden bridges along the W&A route between Atlanta and Chattanooga.

Andrews, the civilian, is a bit of a mystery. He was a native of Hancock County, now West Virginia. He appears to have been a smuggler running

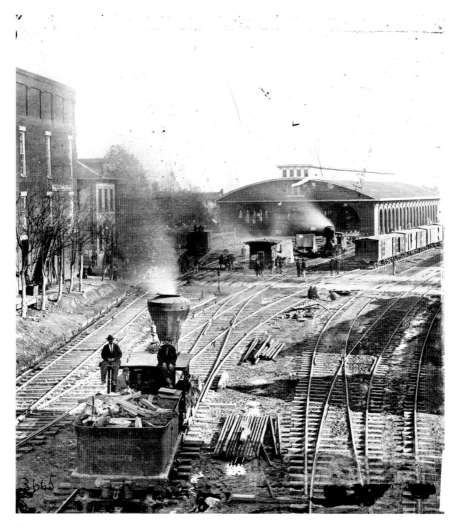

Western & Atlantic car shed (the first Union Station), 1864. *Courtesy Library of Congress.*

contraband between the lines. How he ended up leading a military expedition behind enemy lines is not altogether clear.

The General had arrived in Big Shanty at about 6:00 a.m. Most of the passengers (and all of the crew) left the train and headed to the Lacy Hotel. It was at this moment that Andrews and his raiders struck. After uncoupling the passenger cars from the rest of the train, the three raider locomotive engineers and Andrews jumped in the cab while the rest of the sixteen raiders piled into the three boxcars still coupled to the train. The General headed

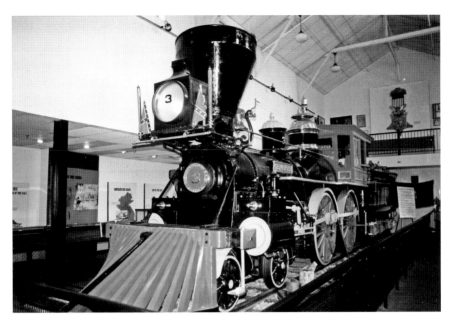

The General at the Southern Museum of Civil War and Locomotive History. *Photo by Robert C. Jones.*

north under the hand of engineer William J. Knight. Within seconds, the train crew began the chase on foot.

The raid entered into legend because the conductor of the train, William A. Fuller, and Western & Atlantic Railroad superintendent of motive power Anthony Murphy pursued the stolen train for eighty-seven miles, by foot, handcar and three different locomotives, until the train was finally abandoned two miles north of Ringgold, Georgia.

The raiders spent the night prior to the raid at the Fletcher House in Marietta, Georgia. They boarded the northbound train pulled by the General at about 5:00 a.m. on April 12, 1862. The Fletcher House, now called the Kennesaw House, still stands in downtown Marietta near the reconstructed railroad depot.

On April 12, 1862, at about 6:00 a.m., the Confederate locomotive General, hauling a passenger train from Atlanta to Chattanooga, made a scheduled twenty-minute stop at the four-room Lacy Hotel in the town of Big Shanty, Georgia (now Kennesaw, Georgia). At 6:10 a.m., James Andrews and twenty Union spies seized the engine and three boxcars and began their fateful trip north.

The General is on display in the Southern Museum of Civil War and Locomotive History in downtown Kennesaw. Below the Southern Museum,

on Main Street, is a monument to the "Great Locomotive Chase" and a second monument to William Fuller.

Moons Station, located about two miles north along the old W&A railroad right of way, was the site where Andrews stopped momentarily to "borrow" some tools from an obliging railroad crew. These tools included a crowbar later used to tear up track. This is also where Fuller and Murphy picked up the now famous "pole car" or "truck-car" used to pursue the raiders all the way to the Etowah River. Today, there is a Georgia state historical marker at the site.

The Etowah River Bridge was the first main target of Andrews's master plan. He made a decision not to destroy the bridge, as the Cooper Iron Works locomotive Yonah was in sight on a nearby spur track. The decision not to destroy the bridge (and the Yonah) proved to be definitive, as the Yonah was the first locomotive used by Fuller and Murphy in the chase. The stone piers of the Etowah River Bridge still stand silent sentinel in the Etowah River (the "new" railroad bridge, built in December 1944, is to the west).

The Yonah, the first locomotive used to pursue Andrews and his raiders, was in use at Cooper Furnace, located on the banks of the Etowah River. The ironworks were operated by Major Mark Cooper from 1847 to 1862, hence the name it still bears today.

Cooper Furnace contains the ruins of the furnace, and the railroad spur that led to the W&A mainline is still visible, especially as you get closer to the park entrance. The park is open free to the public from March to November.

The raiders stopped for wood and water at Cass Station. The overeager tender, William Russell, gave Andrews a W&A schedule, thinking that he was helping the Confederate war effort. (Andrews had told Russell that the General was taking much-needed ammunition to General Beauregard.) The old depot at Cass Station is gone, but there are factory ruins to the immediate east.

Andrews was delayed at Kingston for sixty-five minutes because of a three-section southbound freight. Fuller arrived a mere four minutes after Andrews pulled out of Kingston. (Fuller later claimed that he made the fourteen-mile trip from the Etowah River to Kingston in the Yonah in fifteen minutes.) The Yonah was abandoned, and Fuller and Murphy navigated the complicated Kingston rail yard on foot. The Rome Railroad locomotive William R. Smith was appropriated next by Fuller and Murphy. The old depot is gone, but one can still see where the Rome Railroad connected to the W&A mainline.

Andrews was once again delayed at the Adairsville station. Just south of Adairsville, Fuller was forced to abandoned the William R. Smith and

continue pursuit in the famous Texas. The 1847 railroad station in Adairsville contains a small museum dedicated to the chase. Next to the museum is a marble monument that mentions the event.

At Calhoun, Fuller picked up Dalton telegrapher Edward Henderson, who had come south to see why the telegraph lines were down. Henderson successfully sent a telegraph to Chattanooga from Dalton. Also, the raiders cut telegraph wire and released the first boxcar between Calhoun and Resaca (the Oostanaula River). The 1847 depot at Calhoun is still standing and is now owned by the City of Calhoun.

The Oostanuala River Bridge in Resaca, Georgia, was one of the primary targets for destruction by Andrews raiders. The wet, soggy conditions kept the wooden covered bridge from catching fire. The stone ramparts of the modern railroad bridge date from the time of the raid.

The Texas, now in close pursuit of the General, stopped briefly at the 1847 Dalton depot to drop off telegrapher Edward Henderson. From Dalton, Henderson telegraphed to Chattanooga about the stolen train. Two miles north of Dalton, the raiders blocked the tracks and cut the telegraph wires, but the message had already been sent. The depot at Dalton is still standing and now operates as a restaurant and tavern called the Dalton Depot.

The 1849 Tunnel Hill was a major target of the Andrews Raid. Andrews failed to destroy the tunnel, as the pursuing Texas was within sight by that time. The stone building by the tracks is the original 1849 depot. The old tunnel is now part of a park, which includes a visitors' center. The use of the old tunnel was discontinued in 1928, when a new tunnel was built next to it.

The 1849 railroad depot was standing in Ringgold when the Andrews raiders, nearly out of wood and water for the General, limped past in 1862. The great chase ended two miles north of the old depot, when the raiders abandoned the General and scattered into the woods. The old depot is still standing and has been recently renovated. There is a stone marker commemorating the end of the chase located two miles north of the depot (SR 151).

All of the raiders were captured: eight were hung, including James J. Andrews; eight subsequently escaped and made it back to Union lines; and six were involved in a prisoner exchange. Twenty of the twenty-two original military members of the raid received the Congressional Medal of Honor. As a civilian, Andrews did not receive the award.

While the Andrews Raid (or the Great Locomotive Chase, as it is often referred to since the 1956 movie of the same name produced by Disney) is the most famous Civil War involvement of the Western & Atlantic, it was not the most important from a strategic point of view.

In September 1863, Longstreet's Corps was moved from Virginia to Georgia by train to fight in the Battle of Chickamauga (arriving in time to join the battle on the second day). The last leg of the trip was on the W&A, stopping at Coosa Station (near Ringgold, Georgia).

But the real strategic importance of the W&A came between May and November 1864, when William Tecumseh Sherman used the W&A as his supply line during the Atlanta Campaign. Sherman would later make the following statement about the W&A in a letter to Joseph M. Brown, son of the wartime governor:

> *The Atlanta Campaign of 1864 would have been impossible without this road, that all our battles were fought for its possession, and that the Western and Atlantic Railroad of Georgia "should be the pride of every true American" because, "by reason of its existence the Union was saved."*

On September 2, 1864, Atlanta surrendered to Sherman's army. Soon after Sherman seized the city of Atlanta, the United States Military Railroad (USMRR) began running trains into Atlanta on the W&A.

The Confederate army and W&A management destroyed much of the rolling stock of the W&A so that it couldn't be seized by Sherman's troops. The General was rendered inoperable by retreating Confederate troops.

During the fall of 1864, the W&A was used as the primary supply line for Sherman's troops in Atlanta. Confederate general John Bell Hood briefly interrupted that supply line in early October 1864 when Confederate troops succeeded in destroying fifteen miles of track of the W&A from Big Shanty to Allatoona Pass. On October 5, 1864, the Union again seized control of the W&A after the victory at the Battle of Allatoona Pass. Allatoona Pass was a Union victory partially because Union brigadier general John Corse rushed men to the Union fortification at Allatoona Pass via the Rome and W&A Railroads the night before the battle.

Corse managed to ship 1,054 men from Rome to Allatoona Pass in time for the battle (joining 890 men already there under the command of Lieutenant Colonel John E. Tourtellotte). However, the railroad transit was fraught with difficulties—a good indication of the shape of southern railways by 1864:

> *The train, in moving down to Rome, threw some fourteen or fifteen cars off the track, and threatened to delay us till the morning of the 5th, but the activity of the officers and railroad employees enabled me to secure a train of twenty cars about 7 p.m. of the 4th. Onto them I loaded three regiments*

"Ruins of the passenger station (car shed), Atlanta, Ga.—Nov. 1864." *Courtesy Library of Congress.*

of Colonel Rowett's brigade and a portion of the Twelfth Illinois Infantry, with about 165,000 rounds of ammunition, and started for Allatoona at 8.30 p.m., where we arrived at 1 a.m. on the morning of the 5th instant, immediately disembarked, and started the train back, with injunctions to get the balance of the brigade and as many of the next brigade as they could

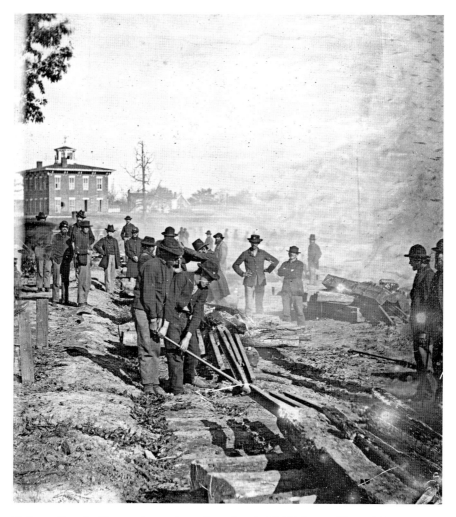

"Atlanta, Georgia. Sherman's men destroying railroad: 1864." *Courtesy Library of Congress.*

carry and return by day-light. They unfortunately met with an accident that delayed them so as to deprive me of any re-enforcements until about 9 p.m. of the 5th.

On November 9, 1864, Sherman issued orders to destroy the W&A from Big Shanty to the Chattahoochee, as he prepared for the March to the Sea:

In accordance with instructions from Major-General Sherman, commanding MILITARY DIVISION of the Mississippi, corps commanders will have their

commands in readiness to march at a moment's notice to commenced the complete destruction of the railroad.....From Big Shanty to a point eleven miles south will be destroyed by the Seventeenth Army Corps, and thence to the Chattahoochee bridge by the Fifteenth Corps. The destruction will be most complete, the ties burned, rails twisted, &c., as [has] been done heretofore.

During the destruction of Atlanta, W&A infrastructure was especially hit, with damage done to track, rolling stock and the W&A train shed. The famous "Sherman's Neckties" (heating the center of a rail and then wrapping it around a pole or tree) were used in many instances to ensure that the W&A would not be able to quickly be repaired.

However, twenty-eight W&A locomotives and a number of cars were salvaged by the Confederacy from the Atlanta disaster by shifting them to Griswoldville (ten miles east of Macon). Union troops seized Griswoldville on November 22, 1864, during Sherman's March to the Sea.

On September 25, 1865, control of the W&A was returned to the State of Georgia. Not much of the railroad was in running condition at that time, as a report from that year notes: "A patchwork of damaged and crooked rails, laid on rotten cross-ties and or rough poles and other makeshifts, eight miles of track at the upper end was entirely missing and the rolling stock was more nearly fit for the scrap heap than for traffic."

Postwar

In 1870, during Reconstruction, Foster Blodgett was named supervisor of the W&A. Blodgett was a close ally of Radical Republican governor Rufus B. Bullock. Blodgett fired several hundred W&A employees and replaced them with his own appointees. Famous conductor William A. Fuller was "discharged for being a Democrat."

Also in 1870, the State of Georgia decided that it no longer wanted to be in the railroad business and sought a way to remove Blodgett from his position as supervisor. Georgia passed legislation that required the leasing of the W&A (the State of Georgia would continue to own the right of way, as it does today). On December 27, 1870, a group led by former governor Joseph E. Brown (no potential for conflict of interest in *that* deal) won the first lease of the W&A. The lease was for twenty years, for $25,000 per month.

On December 27, 1890, the W&A was leased by the Nashville, Chattanooga & St. Louis Railway (NC&StL), although it continued to

operate under the Western & Atlantic name until 1919, when it became the Atlanta Division of the NC&STL RY. The NC&StL lease was for twenty-nine years at $35,001 per month. Essentially, the W&A as an independent entity had ceased to exist in 1890.

In 1957, the Nashville, Chattanooga & St. Louis Railway merged with (or was absorbed by) the Louisville & Nashville Railroad, and L&N became the new name for the old W&A right of way. More corporate shuffling would occur between 1957 and the end of the twentieth century. In 1972, the Family Lines name was adopted to identify the Seaboard Coast Line, L&N, CC&O, the Georgia Railroad and the West Point Route. On November 1, 1980, the CSX Corporation was formed, resulting from the merger of the Chessie System and the Seaboard Coast Line. CSX operates under a lease from the State of Georgia on the old W&A today.

So, what happened to the locomotives from the Great Locomotive Chase? On April 14, 1962, the reconditioned General ran under its own steam from Tilford Yard in Atlanta to Chattanooga. On April 12, 1972, the Big Shanty Museum (now the Southern Museum of Civil War and Locomotive History) opened to the public in Kennesaw, Georgia, to house the General, 110 years after the Andrews Raid.

For many years, the pursuing locomotive, the Texas, was displayed in the Cyclorama in Grant Park, Atlanta. It is currently being reconditioned in North Carolina and will soon be on display at the Atlanta History Center.

Chapter 3

1865–1900

In addition to the five railroads that we highlighted in the last chapter, there was a plethora of new railroads in Georgia after the Civil War. Some were built by local financiers and others by railroad tycoons with plans for regional or even nationwide railroad systems. By the end of the century, most had been consolidated into the Southern Railway, the Atlantic Coast Line and the Seaboard Air Line.

ATLANTA & CHARLOTTE AIR LINE RAILWAY

In 1870, the Atlanta & Richmond Air Line Railway was chartered in North Carolina. While the railroad never reached Richmond on its own track, by September 1873, it was complete from Charlotte to Atlanta. In 1877, the Atlanta & Richmond Air Line Railway went into receivership.

This made it a tempting target for Thomas Clyde, who had visions of a regional, and perhaps transcontinental, railroad. In 1877, he acquired the railroad for his Piedmont Air Line Railway and changed the name to Atlanta & Charlotte Air Line Railway. Service to Richmond would be provided by his Richmond & Danville Railroad. In 1881, the Atlanta & Charlotte Air Line Railway was leased to the Richmond & Danville Railroad in perpetuity. From 1881 to 1894, the Atlanta & Charlotte Air Line Railway was operated by the Richmond & Danville Railroad.

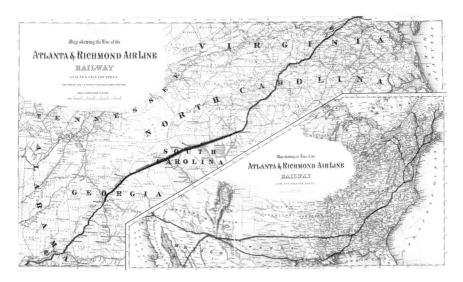

Atlanta Richmond Air Line Railway map.

In 1894, the Southern Railway absorbed the Atlanta & Charlotte Air Line Railway, as well as its parent company, the Richmond & Danville Railroad.

One side note: both the Roswell Railroad and the Elberton Air Line Railroad connected with the Atlanta & Charlotte Air Line Railway, the latter at Roswell Junction, which later would be called Chamblee, Georgia.

Atlanta & Florida Railway

Here is a good trivia question for Georgia railroad buffs. Name a railroad that went from Atlanta to (near) Macon that was not named the Macon & Western? The answer is the Atlanta & Florida Railway. Not exactly a household name here in the twenty-first century.

In July 1886, the Atlanta & Hawkinsville Railroad was chartered, and while it never actually reached Hawkinsville, it did eventually reach Fort Valley, southwest of Macon. In 1887, the name was changed to Atlanta & Florida Railroad (a bit more cosmopolitan a name than the Atlanta & Hawkinsville Railroad). In 1887, the railroad reached Fayetteville, Georgia, from Atlanta, and in November 1888, it reached Fort Valley, Georgia.

After incurring financial problems, the Atlanta & Florida Railroad was reorganized as the Atlanta & Florida Railway in 1893. But it was not to

survive as a separate corporate entity for very much longer. In June 1895, it was purchased by J.P. Morgan and integrated into the Southern Railway.

Little of the line exists today. In 1939, the Roseland (McDonough Boulevard and Jonesboro Road in the Atlanta area) to Williamson line was abandoned, and in 1977, the Williamson to Roberta line was abandoned. Also, there are no buildings of the A&F left in Atlanta, as they leased stations and depots from the East Tennessee, Virginia & Georgia in Atlanta.

Brunswick & Albany Railroad

In terms of its charter date (1835), the Brunswick & Florida Railroad could have been included in our list of pre–Civil War railroads in Georgia. However, no track was laid until 1861, when the line opened from Brunswick to Waynesville (twenty-five miles). New investors renamed it the Brunswick & Albany Railroad.

In 1863, in what must have been a grave indignity to the owners of the Brunswick & Albany Railroad, the Confederate government decided to tear up the rails (about sixty-five miles worth, Brunswick to Waycross) on the Brunswick & Albany Railroad to use in other, more strategic places. This reflected on the lack of adequate rail manufacturers (rolling mills) in the Confederacy. The Brunswick & Albany recovered after the war, though, and in May 1869, track was completed from Brunswick to Waycross (Tebeauville).

In March 1870, carpetbagger Hannibal Kimball accepted a proposal as a contractor to build the rest of the Brunswick & Albany Railroad. A few months later, in November 1870, he assumed the presidency of the Brunswick & Albany Railroad. He quickly got construction into high gear, as two hundred state convicts were added to the workforce. While slavery was no longer legal in the South, cheap labor was still available through the use of convict laborers. (Former governor Joseph Brown got rich using convict labor to mine coal after the war.) In October 1871, track was finally completed between Brunswick and Albany (172 miles).

In November 1871, one year after he became president of the Brunswick & Albany Railroad, Hannibal Kimball resigned and fled the state, with creditors and multiple charges of state corruption close behind him.

In 1872, the Brunswick & Albany Railroad went into receivership and was reorganized soon after. In December 1882, it was reorganized yet again, as the Brunswick & Western Railroad. It was often referred to by

the marketing name Ty-Ty Route (after a town along the route, located west of Tifton, Georgia).

In 1888, the Brunswick & Western Railroad ceased to exist as an independent corporate entity when it was purchased by Henry B. Plant and the Savannah, Florida & Western Railroad.

CARTERSVILLE & VAN WERT RAILROAD

The Cartersville & Van Wert Railroad was chartered in 1866. Today, it is hard to imagine why someone would want to build a railroad to Van Wert, Georgia, which no longer exists as an incorporated town (there are still a few "Van Wert" place names south of Rockmart). But in the postwar period, it was a hotbed of slate mining activity. The goal was probably to eventually link the Cartersville & Van Wert Railroad with the Selma, Rome & Dalton Railroad to the west.

In January 1870, carpetbagger Hannibal Kimball agreed to act as a contractor to build the railroad from Cartersville. By November 1870, he had laid fourteen miles of track from Cartersville to Taylorsville. At this point, Kimball leaves our story (and the state).

Meanwhile, in October 1870, the name of the Cartersville & Van Wert Railroad was changed to Cherokee Railroad after it was purchased by the Cherokee Iron Company. The line was extended to Cedartown (twenty-two miles). It appears that it never actually got to Van Wert, the original objective.

In 1881, the decision was made to convert the Cherokee Railroad to standard gauge. The first section upgraded was the Cartersville–Taylorsville leg. By 1887, the whole system had been upgraded to standard gauge. Also in 1881, new track was laid to Esom, Georgia (near the state line with Alabama).

In 1882, the Cherokee Railroad was leased to the East & West Railroad of Alabama. The E&WA Railroad soon built sixty-four miles of track from Esom, Georgia, to Coal City (Wattsville), Alabama.

In 1887, seven miles were built from Coal City, Alabama, to Pell City, Alabama, where it connected to the Georgia Pacific Railroad. Suddenly, the somewhat quixotic Cartersville & Van Wert Railroad was turning into something reasonably significant.

Alas, by 1888, the East & West Railroad of Alabama was in receivership, where it remained until 1893, when the Kelly brothers of New York purchased

the railroad and renamed it the East & West Railroad. Their interest was to develop mining properties near the route of the E&W Railroad.

In 1896, the Kelly brothers completed building the Tredegar Mineral Railway (Tredegar, Alabama, to Jacksonville, Alabama) to haul ore four miles from their mines to the E&W Railroad. The same year, the E&W Railroad and the Tredegar Mineral Railway merged.

In 1903, John Skelton Williams, president (and creator) of the Seaboard Air Line, formed the Atlanta & Birmingham Air Line Railway, a wholly owned subsidiary of the Seaboard Air Line, with the intent of having it absorb the E&W Railroad (which soon happened). By 1909, the Atlanta & Birmingham Air Line Railway had been absorbed into the Seaboard Air Line Railway.

CHATTANOOGA, ROME & COLUMBUS RAILROAD

In 1887, the Rome & Carrollton Railroad was chartered. By the next year, twenty miles of track had been built south from Rome toward Carrollton.

Also in 1888, the Rome & Carrollton Railroad was reorganized as the Chattanooga, Rome & Columbus Railroad. Soon, forty-one more miles of track had been built south toward Carrollton.

In 1889, the Chattanooga, Rome & Columbus Railroad built seventy-seven miles of track from Rome to Chattanooga. Not surprisingly, this flurry of track building in extreme northwest Georgia caught the attention of the Central Railroad. The Central was examining ways to get a route to Chattanooga.

By 1890, the Chattanooga, Rome & Columbus Railroad, possibly worn out from building 138 miles of track between 1887 and 1889, was basically out of money. The Central Railroad was happy to purchase the CR&C Railroad, at the instigation of Central president E. Porter Alexander.

Later in 1890, the Chattanooga, Rome & Columbus Railroad and the Savannah, Griffin & North Alabama Railroad (also owned by Central Railroad) merged, giving the Central Railroad a Savannah–Chattanooga route (in conjunction with the Savannah & Western Railroad). The SG&NA operated from Griffin to Carrollton and the S&W from Savannah to Griffin.

In 1894, the Central Railroad went into receivership, and the Chattanooga, Rome & Columbus Railroad was returned to its original owners by the courts.

In 1897, the Chattanooga, Rome & Columbus Railroad, once again in financial trouble, was sold to Simon Borg and Company and was renamed the Chattanooga, Rome & Southern Railroad. In 1900, the CR&S bought the Chattanooga & Durham Railroad, a Lookout Mountain coal railroad.

On May 16, 1901, the Central of Georgia Railway repurchased the Chattanooga, Rome & Southern Railroad and finally had its route to Chattanooga.

COVINGTON & MACON RAILROAD

In 1886, the Covington & Macon Railroad Company was chartered by former Confederate officers Colonel Lon Livington and Colonel E. C. Machento to build a railroad from Macon to Covington (Covington is located east of Atlanta). By 1887, track had been completed from Macon to Hillsboro, and in June of that year, as track was completed into Monticello, the decision was made to build to Athens instead of Covington. This decision was made to attract new investors.

In March 1888, track was completed to Madison, Georgia. And then, in 1889, the complete Macon–Athens line opened (102 miles). Meanwhile, in 1887, the company was sold at public auction and renamed the Macon & Northern Railroad.

In 1891, John Inman of the Richmond Terminal Company agreed to buy the debt-ridden Macon & Northern Railroad. It was leased to the Central Railroad.

In March 1892, the Central Railroad went into receivership, dragging the Macon & Northern Railroad with it. Shortly after, owner Alexander Brown successfully petitioned the courts to separate the M&N bankruptcy from the Central Railroad bankruptcy.

This worked out well for Brown because in 1894 he was able to buy the rest of the shares at bargain prices and became the sole owner. The line was then renamed the Macon & Northern Railway.

In 1895, the directors of the Central of Georgia Railway purchased the Macon & Northern Railroad.

East Tennessee, Virginia & Georgia Railroad

The East Tennessee, Virginia & Georgia Railway was one of three main railroads that were consolidated in 1894 by J.P. Morgan to create the Southern Railway. The ETV&G was in operation in Georgia before the Civil War but was not a Georgia railroad.

On February 4, 1848, the Hiawassee Railroad was reorganized as the East Tennessee & Georgia Railroad to build a railroad from near Knoxville (Loudon) to link up with the Western & Atlantic at Dalton. Meanwhile, in 1850, the East Tennessee & Virginia Railroad was chartered in Tennessee to build a line from Bristol to Knoxville.

By 1852, the East Tennessee & Georgia Railroad had been completed from Loudon, Tennessee, to Dalton, Georgia, and was able to link up with the W&A, which was finished in 1850. In 1859, the East Tennessee & Georgia Railroad entered Knoxville when a bridge was built over the Tennessee River.

In 1869, the ET&G and ET&V railroads merged, forming the East Tennessee, Virginia & Georgia Railroad. The 212-mile route ran from Bristol, Virginia, to Dalton, Georgia.

In 1880–81, the East Tennessee, Virginia & Georgia Railroad bought the Georgia Southern Railroad (Selma, Rome & Dalton Railroad), giving it further access into Georgia and also into Alabama. Expansion continued in

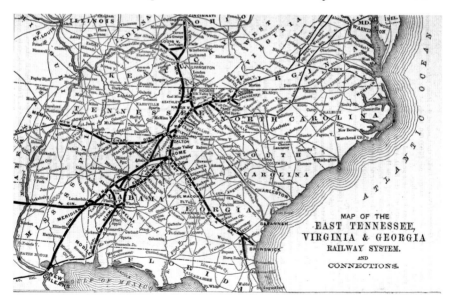

Poor's East Tennessee, Virginia & Georgia Railway map, 1891.

1881 as the ETV&G bought the Macon & Brunswick Railroad, a 174-mile road between Macon and Brunswick. To connect these widely separated lines, the ETV&G built its "Atlanta Division" from Rome to Atlanta to Macon, a distance of 158 miles. It was completed in 1882.

In 1885, William Clyde, son of Thomas Clyde, assumed the presidency of the Richmond Terminal Company. The next year, 1886, the RTC bought the East Tennessee, Virginia & Georgia Railroad from receivership, and it became the East Tennessee, Virginia & Georgia *Railway*. By 1889, the ETV&G was operating 1,465 miles of right of way.

In 1894, the East Tennessee, Virginia & Georgia Railway and the Richmond & Danville railroad were consolidated by J.P. Morgan to form the Southern Railway.

GAINESVILLE MIDLAND RAILWAY

In 1872, the Gainesville, Jefferson & Southern Railroad was chartered as a narrow-gauge (three-foot) railroad. Not much seemed to happen with the Gainesville, Jefferson & Southern Railroad until, in 1884, the Georgia Railroad (co-leased by the Central Railroad and Louisville & Nashville Railroad) assumed control of the GJ&S. That year, the Gainesville, Jefferson & Southern Railroad was completed to Monroe, as well as a branch from Belmont to Jefferson (ten miles).

Also in 1884, the GJ&S purchased the Walton Railroad, with the help of the Central Railroad and Louisville & Nashville Railroad, giving them access to Social Circle and the Georgia Railroad. By 1885, the GJ&S was known as the Jug Tavern Route, after a tavern that sold liquor by the jug in what would later be Winder.

In 1897, the Gainesville, Jefferson & Southern Railroad went into receivership. Relief came in 1904 when investors bought the Monroe–Social Circle portion of the bankrupt GJ&S, and G.J. Baldwin bought the Gainesville–Monroe portion of the Gainesville, Jefferson & Southern Railroad, which was renamed the Gainesville Midland Railway.

In 1906, a standard-gauge extension was built from Jefferson to a connection with the Seaboard Air Line near Athens at Fowler Junction. In 1908, tracks from Jefferson to Gainesville were converted to standard gauge, and in 1913, the Monroe Branch (Belmont to Monroe) was also converted to standard gauge.

In 1938, the Gainesville Midland Railroad was purchased by the Georgia Car & Locomotive Company, headed by Forest Greene, for $127,000 and the assumption of the railroad's debt. Greene ran gasoline-powered buses on the rail for passenger service to save money. In 1947–48, the Monroe branch was abandoned.

In 1959, the Gainesville–Athens line was sold to Seaboard Air Line Railroad, which eventually became part of CSX.

GEORGIA MIDLAND RAILWAY

In 1886, the Georgia Midland & Gulf Railroad was chartered to build a line from McDonough to Columbus, Georgia (ninety-nine miles). Convict labor was used to build the railroad, and it was completed by December 1, 1887.

In 1890, the GM&G leased the Columbus & Southern Railway (Columbus to Albany) but pulled out of the lease in a year, as the GM&G couldn't make the payments.

The Georgia Midland & Gulf Railroad shops in Columbus, Georgia (upper right-hand corner), 1886. *Courtesy Library of Congress.*

In 1895, the GM&G entered receivership. The next year, J.P. Morgan purchased the GM&G and renamed it the Georgia Midland Railway. The line was quickly leased to the Southern Railway and was eventually absorbed by the Southern Railway. In 1982, the Georgia Midland Railway became part of Norfolk Southern.

Georgia Northern Railway

One of the last individual entrepreneurs to build a successful mainline railroad in Georgia was James Pidcock Sr. He arrived in Georgia in 1892 to visit his son, Charles. He soon asked his other three sons to join him from New Jersey to start up a timber operation. As a result, they created the town of Pidcock (between Thomasville and Quitman). As the stands of timber to be cut got farther and farther away from Pidcock, a logging railroad was built going twelve miles north of Pidcock to Hollis, Georgia. Around this time, the Boston & Albany Railroad of Georgia was chartered, but the line soon went bankrupt.

On February 26, 1893, the Pidcock's timber railroad reached Moultrie in the north, with Charles Pidcock Sr. as the engineer of locomotive no. 4. The Pidcocks had purchased this locomotive from the defunct Rockaway Valley Railroad in New Jersey (for which the elder Pidcock had once been an officer).

On November 22, 1894, the Pidcocks bought the bankrupt Boston & Albany Railroad of Georgia and renamed it the Georgia Northern Railway. This meant that they now had a common-carrier charter (the Pidcock Railroad was for hauling timber, not people).

By 1894, the Pidcocks had reached Doerun, Georgia (about forty-eight miles from Pidcock). In 1899, James Pidcock Sr. died.

By 1901, the Georgia Northern Railway neared Albany, Georgia (sixty-five miles). In 1904, the Southern terminus of the GN was relocated to Boston, Georgia, from Pidcock, Georgia. The same year, the GN was completed to Albany, where a steel bridge had been built across the Flint River by the Pidcocks.

In 1910, the Pidcocks bought the Flint River & Northeastern Railroad (Pelham to Tichnor, near Doerun, Georgia). Things on the expansion front were pretty quiet for the next few years, until 1922, when the Pidcocks bought the Georgia, Ashburn, Sylvester & Camilla Railway. In 1939, the

Pidcocks acquired the Georgia, Southwestern & Gulf Railroad (Albany to Cordele, about thirty-nine miles). In 1946, the Flint River & Northeastern line was abandoned.

In May 1966, the Southern Railway acquired the Georgia Northern.

Georgia Pacific Railroad

The grandiosely named Georgia Pacific Railroad was formed by Thomas Clyde in 1881, with former Confederate general John B. Gordon appointed as president. This gave a new opportunity for the Piedmont Air Line to expand to the West. While the short-term goal was to build a line west from Atlanta to Birmingham, the "Pacific" in the name indicated plans to move farther west.

At the same time that the Clydes formed the Georgia Pacific Railroad, they also purchased two small Mississippi railroads—the Greenville, Columbus & Birmingham Railroad (a twenty-three-mile line) and the Greenville, Deer Creek & Rolling Fork Railroad (Stoneville, Mississippi, to Percy, Mississippi).

Construction on the Georgia Pacific Railroad began in 1882 on the Birmingham–Atlanta segment and was officially opened in November 1883.

Thomas Clyde died in 1885, and initially, his son, William, took over as president of the Richmond Terminal Company. In December 1886, William Clyde was forced out as president, and John Inman took his place.

In 1887, Inman authorized further westward expansion of the GP Railroad. As a result, track was extended to Columbus, Mississippi (on the eastern side of the state), in the same year.

In 1888, the Georgia Pacific was reorganized, leased to the Richmond Terminal Company and renamed Georgia Pacific Railway. Soon after, the Georgia Pacific Railway was absorbed by the Richmond & Danville Railroad and became the Georgia Pacific Division. In 1889, the line was completed to Greenville, Mississippi (on the Mississippi River).

The Georgia Pacific Railway was absorbed by the Southern Railway in 1894.

Georgia Southern & Florida Railroad

In 1888, the Georgia Southern & Florida Railroad was chartered by the Macon Construction Company to build a line from Macon, Georgia, to Palatka, Florida (sixty miles south of Jacksonville). The Macon Construction Company was also constructing the Macon & Birmingham Railroad and the Macon & Atlantic Railroad (Macon to Savannah).

Construction proceeded with alacrity. By February 1889, the Macon–Valdosta segment was up and running. By March 1890, the railroad was complete to Palatka, Florida (285 miles).

In 1891, the Georgia Southern & Florida Railroad entered into receivership, with President W.B. Sparks appointed as the court-ordered receiver. In 1895, it was reorganized as the Georgia Southern & Florida Railway under the Southern Railway.

In 1902, the Georgia Southern & Florida Railway bought the Atlantic, Valdosta & Western Railway (Valdosta to Jacksonville), which expanded its operations significantly. By 1917, 392 miles of track were in operation.

The line was often referred to as the "Suwanee River Route," as it crossed the famous river twice—once at White Springs, Florida, and again at Fargo, Georgia. "Old Folks at Home" ("Swanee River") was a famous song written by Stephen Foster in the 1850s.

Today, the Georgia Southern & Florida Railway operates as a subsidiary of Norfolk Southern.

Macon & Brunswick Railroad

The Macon & Brunswick Railroad was chartered in 1856 but didn't lay any track until after the Civil War. In 1867, track was laid from Macon to Hawkinsville and from Brunswick to Jesup. Part of the track crew for the building of the Macon & Brunswick Railroad was composed of involuntary convict labor.

On January 1, 1870, the track between Macon and Brunswick was completed (174 miles). George Hazlehurst was made president (Hazlehurst, Georgia, is named after him). Two trains operated daily.

In 1873, the State of Georgia seized the Macon & Brunswick for unpaid interest on a $2,550,000 bond sold for the benefit of the railroad. The state operated the railroad for the next several years.

In 1881, the Macon & Brunswick was purchased by Thomas Clyde and the East Tennessee, Virginia & Georgia Railroad. To connect the two railroads, the East Tennessee, Virginia & Georgia Railroad decided to build a line that connected the Macon & Brunswick with the ETV&G Railroad (Selma, Rome & Dalton Railroad) in Rome, Georgia. The Cincinnati & Georgia Railroad was formed to build this 141-mile route.

In October 1882, the Rome–Macon line was opened, and the East Tennessee, Virginia & Georgia Railroad took over the Cincinnati & Georgia Railroad.

In 1886, William Clyde (son of Thomas Clyde) and the Richmond Terminal Company took over financial control of the East Tennessee, Virginia & Georgia Railroad, renaming it the East Tennessee, Virginia & Georgia *Railway*. In 1894, both railroads were integrated into the Southern Railway.

Nashville, Chattanooga & St. Louis Railway

We include the Nashville, Chattanooga & St. Louis Railway in our discussion of Georgia railroads not because it was a major player in Georgia but because it leased the venerable Western & Atlantic for sixty-seven years.

The Nashville & Chattanooga Railroad was chartered in Nashville on December 11, 1845. It was the first railroad built in Tennessee. In 1848,

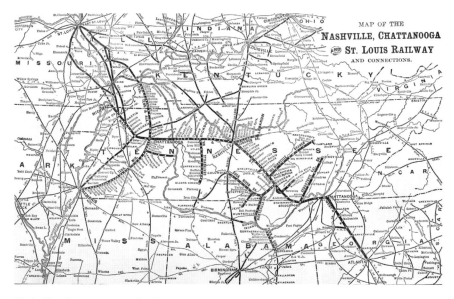

Nashville, Chattanooga & St. Louis Railway map, 1911.

Vernon K. Stevenson was elected president. Construction proceeded slowly. During the spring of 1851, the first train ran on the Nashville & Chattanooga Railroad, traveling eleven miles from Nashville to Antioch, Tennessee. It wasn't until 1860 that the line between Nashville and Chattanooga was completed. In 1863, Union general William Rosecrans attacked along this railroad line during the Tullahoma Campaign.

In 1873, the Nashville & Chattanooga Railroad became the Nashville, Chattanooga & St. Louis Railway (NC&StL). Note that the NC&StL never reached St. Louis.

In 1880, the Louisville & Nashville Railroad took a controlling interest (55 percent of the stock) in the Nashville, Chattanooga & St. Louis Railway through a hostile stock takeover. The L&N would retain this control until 1957, when the NC&StL was absorbed into the L&N.

On December 27, 1890, the Western & Atlantic Railroad was leased by the Nashville, Chattanooga & St. Louis Railway. The original NC&StL lease was for twenty-nine years at $35,001 per month. In 1896, the NC&StL purchased the old Rome Railroad (Kingston to Rome). It was abandoned in 1943.

From 1892 to 1966, the Dixie Flyer operated from Chicago to Florida via Atlanta, partly on NC&StL track.

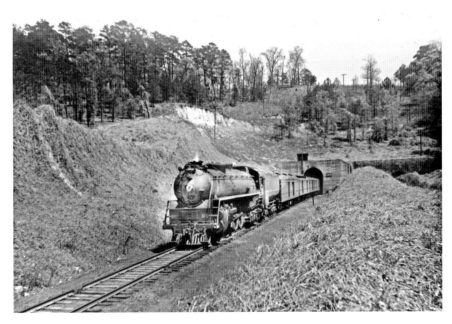

Steam engine thunders through the "new" tunnel at Tunnel Hill, 1940s. *Courtesy of the Bogle family and David Ibata.*

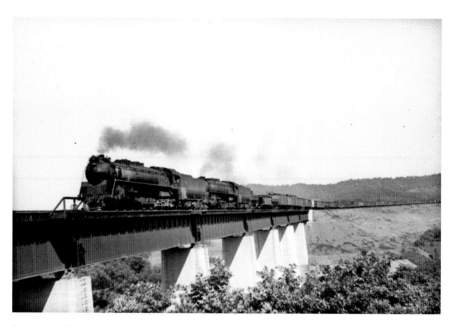

Steam double-header on the Etowah River. *Courtesy of the Bogle family and David Ibata.*

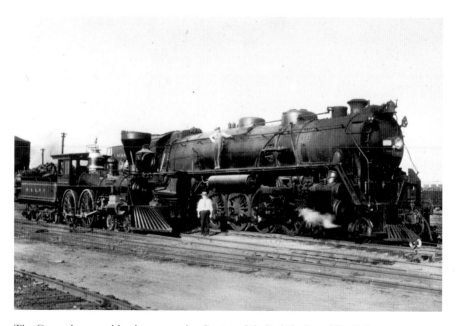

The General poses with a larger cousin. *Courtesy of the Bogle family and David Ibata.*

In 1902, the L&N was acquired by the Atlantic Coast Line Railroad through a stock takeover. Thus, the NC&StL was now owned by the Atlantic Coast Line Railroad, although the NC&StL and L&N continued to operate under their own names for decades.

In 1919, the Nashville, Chattanooga & St. Louis Railway renewed its lease with the State of Georgia for the old W&A right of way for fifty years at $45,000 per month. It was at this point that the nomenclature "Western & Atlantic" faded into history, as it became the Atlanta Division of the NC&StL RY.

During the 1920s, the NC&StL became known as the Dixie Line. By 1925, the NC&StL was operating 1,259 miles of right of way.

In 1957, the NC&StL merged with (or was absorbed by) the Louisville & Nashville Railroad, and L&N became the new name for the old W&A right of way.

In 1967, the Atlantic Coast Line (which controlled the Louisville & Nashville) merged with the Seaboard Air Line Railroad to form the Seaboard Coast Line Railroad (SCL).

In the early 1970s, the SCL officially merged with the Louisville & Nashville Railroad and the Clinchfield Railroad and operated under the marketing title of the Family Lines System. I still occasionally see maps that identify the old W&A as the Seaboard or Family Lines railroads.

In 1986, CSX Transportation was formed when the Seaboard Coast Line merged with the Chessie System.

Plant System

The oldest predecessor of the Plant System is probably the Savannah & Albany Railroad, which was chartered on December 25, 1847. It was renamed the Savannah, Albany & Gulf Railroad in 1853.

In December 1856, the Atlantic & Gulf Railroad was chartered, which was intended to run from Savannah to Thomasville, using tracks of the Savannah & Albany Railroad for the part of the route closest to Savannah.

Not surprisingly, in May 1863, the Atlantic & Gulf Railroad and the Savannah & Albany Railroad merged, retaining the name Atlantic & Gulf Railroad. In 1880, the Plant System purchased the Atlantic & Gulf Railroad of Georgia at a foreclosure sale, and Henry Plant became president of the newly named Savannah, Florida & Western Railroad.

Cover to a Plant System publicity book.

Plant quickly began expanding his railroad empire, sometimes through acquisitions and sometimes through constructing new branch lines. Unlike most other railroad entrepreneurs of the time, he paid for his acquisitions from current operating funds as opposed to taking on a large debt load. His expansion projects were many and varied:

- 1880: purchased the Savannah & Charleston Railroad at a foreclosure sale;
- 1881: SF&W built a seventy-five-mile line from Waycross, Georgia, to Jacksonville, Florida, via Folkston, Georgia;
- 1882: created the Plant Investment Company, which he used to manage his railroad properties;
- 1882: expanded the Savannah, Florida & Western Railroad from Bainbridge, Georgia, to Chattahoochee, Florida, where it linked up with the L&N-controlled Pensacola & Atlantic Railroad;
- 1884: expanded the Savannah, Florida & Western Railroad from Live Oak, Florida, to Gainesville, Florida;
- 1887: purchased the Brunswick & Western Railroad

Not content to be restricted to land-based transportation methods, Plant in 1886 formed a steamship company (Plant Steamship Line), which operated from Mobile to Tampa and from Tampa to Havana.

In the late 1880s, Plant decided that one way to attract passengers to Florida as tourists was to build hotels. From 1887 to 1898, Plant built hotels in Sanford, Punta Gorda, Port Tampa, Kissimmee, Fort Myers, Clearwater and other locations. The Tampa Hotel, which cost $3 million to build, was used as a staging area during the Spanish-American War.

Plant died on June 23, 1899, in New York City. His Plant System operated 1,500 miles of track in Georgia and Florida in 1900.

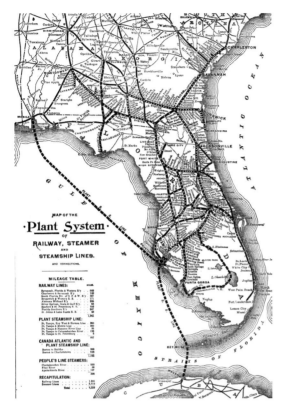

Plant System map, 1895.

Although Plant had attempted to take steps to ensure that his empire would stay intact, shortly after he died, his second wife and one of his sons sold most of the Plant System to the Atlantic Coast Line.

One more item must be noted. On March 1, 1901, a Savannah, Florida & Western train set an unofficial steam locomotive speed record from Savannah to Jacksonville, traveling 149 miles in 130 minutes. As a result of this feat of speed and derring-do, the Plant System was awarded a mail contract.

ROSWELL RAILROAD

In 1853, Roswell King, owner of the massive Roswell Manufacturing Company in the town named after him, received authority from his shareholders to build a narrow-gauge railroad, but no direction was specified. There were two options at the time: build west toward the Western & Atlantic or south toward Atlanta. Nothing happened regarding the construction of the railroad until after the Civil War.

On April 10, 1863, the Roswell Manufacturing Company received a charter from the Confederate government to build a narrow-gauge (three-foot) railroad to carry both freight and passengers. Again, no track was laid, and on July 5, 1864, the mills at Roswell were destroyed by William Tecumseh Sherman's forces under cavalry general Kenner Garrard.

By 1867, the 1853 mill destroyed by Sherman had been rebuilt, and in 1870, the old plans for constructing a railroad from Roswell south were dusted off, as the Atlanta & Richmond Air Line Railway announced plans to build a line from Charlotte to Atlanta.

In 1877, the Atlanta & Charlotte Air Line Railway (formerly the Atlanta & Richmond Air Line Railway) was purchased by Thomas Clyde to be part of his Piedmont Air Line Route. The Atlanta & Charlotte Air Line Railway became part of the Richmond Terminal Company (also owned by Clyde).

In 1881, the Richmond Terminal Company provided financial assistance to the Roswell Railroad to help it reach the junction (Roswell Junction) with the Atlanta & Charlotte Air Line Railway. Thomas Clyde then bought all of the stock in the Roswell Railroad.

On September 1, 1881, the Roswell Railroad opened for business. The ten-mile line went north from Roswell Junction (now Chamblee) to the south side of the Chattahoochee River. A bridge was never built, so the railroad didn't actually enter into the city of Roswell itself. The northern terminus was near what is now the North River Village Shopping Center in Sandy Springs.

In 1887, the Richmond Terminal Company absorbed the Roswell Railroad into the Richmond & Danville Railroad and renamed it the Roswell Branch. Around the same time, the depot at Roswell Junction changed its name to Chamblee. The origin of the name remains obscure. In 1908, the town of Chamblee was incorporated as a half mile in each direction from the old railroad depot.

In 1894, the Roswell Railroad was absorbed into the Southern Railway.

In 1902, a 2.75-mile branch line, called the Morgan Falls Branch (or Bull Sluice Railroad), opened just north of the Dunwoody Station to deliver materials to a dam and power plant construction site. It would only be in use for two years and then was abandoned. A small portion of the roadbed can be seen at the Big Trees Forest Preserve on the poorly maintained Jackson Overlook Trail.

In 1903, the Southern Railway converted the narrow-gauge railroad to standard gauge. Beginning the same year, and lasting until 1920, two trains operated daily on the Roswell Railroad, from Chamblee through Dunwoody to Roswell. In 1905, President Theodore Roosevelt traveled on the Roswell Railroad to visit Bulloch Hall in Roswell.

In 1920, the depots at Chamblee and Dunwoody were closed, and the Roswell Railroad became a memory.

The Elberton Railroad was another railroad that served as a narrow-gauge feeder line for the Atlanta & Richmond Air Line Railway. It ran from Elberton to Toccoa. Thomas Clyde purchased it in 1881.

Savannah & Western Railroad

On October 9, 1885, the Central of Georgia created the Savannah & Western Railroad as a wholly owned subsidiary, with the intention of creating an Americus–Columbus–Birmingham line. There were several other mergers and acquisitions involving the Savannah & Western Railroad in 1888. On June 18, 1888, the Columbus & Western Railway (Columbus to Birmingham) merged with the Savannah & Western Railroad. The S&W Railroad acquired the East Alabama & Cincinnati Railway (Opelika to Roanoke, Alabama) and the Buena Vista & Ellaville Railroad (Americus to Buena Vista, Georgia). The Eufaula & Clayton Railway (Clayton, Alabama, to the Gulf) and the Eufaula & East Alabama Railroad merged into the Savannah & Western Railroad.

In May 1890, fifty-seven miles of track were completed between Meldrim and Lyons (east of Savannah). On November 26, 1890, the Savannah & Western Railroad acquired the Savannah, Griffin & North Alabama Railroad (Griffin to Carrollton).

Continuing on its acquisition strategy, in 1891 the Savannah & Western Railroad acquired the Chattanooga, Rome & Columbus Railroad (Chattanooga and Carrollton).

In 1894, the S&W Railroad was dragged into receivership with the rest of the Central of Georgia empire. As a result, the S&W lost the Chattanooga, Rome & Columbus Railroad.

On October 5, 1895, the S&W Railroad was sold by order of a judge, but two months later, it was conveyed to the Central of Georgia Railway. In 1896, the Meldrim-Lyons line was leased to the Georgia & Alabama Railway.

Savannah, Americus & Montgomery Railway and Georgia & Alabama Railway

In 1884, the narrow-gauge Americus, Preston & Lumpkin Railroad was formed. By 1887, it had 104 miles of track in operation.

In December 1888, the Savannah, Americus & Montgomery Railway was formed as the successor to the Americus, Preston & Lumpkin Railroad. In 1889–90, the narrow-gauge track from Louvale to Americus to Abbeville was upgraded to standard gauge. Abbeville was of some

strategic importance at the time, as the SA&M maintained a fleet of five riverboats on the Ocmulgee River (and, to the east, Altamaha River) that traveled to Georgia's coastal cities. (The need for these boats disappeared after Williams built the line into Savannah.)

In 1889, trackage agreements between the Savannah, Americus & Montgomery Railway and the Central Railroad were brought into force. The Savannah & Western Railroad (owned by the Central Railroad) was given rights on the Lyons-Americus portion of the SA&M Railway, and the SA&M Railway gained access from Lyons east to Savannah.

In June 1890, an extension from Abbeville to Lyons was made, joining the SA&M Railway with the Savannah & Western Railroad. Also in 1890, an extension was completed from Louvale to the Chattahoochee River. The next year, tracks were completed to Montgomery, Alabama. The SA&M Railway now had 265 miles of right of way.

In 1892, the Savannah, Americus & Montgomery Railway created the Albany & Northern Railway to build a line from Cordele to Albany.

In May 1895, the SA&M Railway was sold under foreclosure to Baltimore syndicates (John L. Williams and Sons and Middendorf, Oliver and Company) and renamed the Georgia & Alabama Railway. John Skelton Williams (one of the sons) was named president. The same year, the Cordele Albany line was reorganized as the Albany Northern Railway.

In 1896, the G&A purchased the Abbeville & Waycross Railroad, a short line that ran from Abbeville to Fitzgerald. The same year, the G&A secured a long-term lease from the Central of Georgia for the fifty-eight miles of track between Lyons and Meldrim. The G&A also acquired trackage rights for the Meldrim–Savannah line for four years, the Central of Georgia being careful about who it let into the Savannah neighborhood. Also in 1896, John Skelton Williams purchased the Columbus Southern Railway (Columbus to Albany).

Unhappy with the trackage lease into Savannah being for only four years, Williams began building track to Savannah and purchased land in Savannah for dock facilities. To aid with the latter, he created the Georgia & Alabama Terminal Company.

The Georgia & Alabama was sometimes known as the Savannah Short Line, not in reference to the size of the railroad but to the fact that its route from Montgomery to Savannah was shorter than that of the Central of Georgia Railroad and the Plant System.

In 1897, Williams extended the Abbeville & Waycross Railroad nine miles to Ocilla, Georgia.

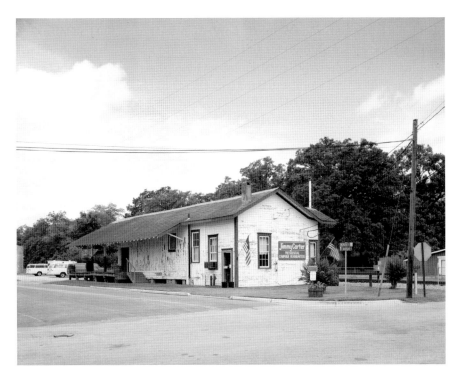

The 1888 Savannah, Americus & Montgomery depot, Plains, Georgia. *Courtesy Library of Congress.*

In February 1899, the Georgia & Alabama Railroad, Seaboard Air Line Railway and the 944-mile Florida Central & Peninsular Railroad agreed to merge, keeping the name Seaboard Air Line Railway. The three railroads were connected after track was built from Cheraw, South Carolina, to Cayce, South Carolina. The SAL now reached from Richmond to Tampa.

Today, the SA&M Railway is a tourist railroad operated by the Georgia Department of Natural Resources.

SAVANNAH, FLORIDA & WESTERN RAILROAD

The significance of the Savannah, Florida & Western Railroad is that it was the beginning of the Plant System. On November 4, 1879, Henry Plant bought the Atlantic & Gulf Railroad out of bankruptcy. On December 5, 1879, it was renamed the Savannah, Florida & Western, with Plant as its president.

In 1881, Plant began laying new track from Waycross through Folkston, Georgia, to Jacksonville, Florida. In 1882–83, the Savannah, Florida & Western built thirty-two miles of track from Climax, Georgia, to Chattahoochee Florida.

In 1884, the Waycross & Florida Railroad, along with several railroads in Florida, were consolidated into the Savannah, Florida & Western.

In 1899, shortly after the death of Henry Plant, the Savannah, Florida & Western Railroad was absorbed by the Atlantic Coast Line.

Southwestern Railroad

In December 1845, the Southwestern Railroad was chartered to build a railroad from Macon to the southwest (eventually Columbia, Alabama). Construction began in 1848. By 1852, track was completed to Oglethorpe, Georgia (Flint River). The next year, the line was extended to Americus, Georgia, after an infusion of cash by the citizens of said town.

Also in 1853, the Southwestern Railroad provided assistance to the Muskogee Railroad (Columbus to Macon) in return for trackage rights into Columbus, Georgia.

In 1856, the Southwestern Railroad charter was amended to allow the building of a branch line south of Americus (Smithville) west to the Chattahoochee at Georgetown, Georgia, to link up with steamboat traffic there. (Yes! Steamboat traffic on the Chattahoochee!)

In 1857, the Southwestern Railroad chartered the Georgia & Florida Railroad to continue the line from Americus to Albany. After Albany was reached, the Georgia & Florida was absorbed into the Southwestern Railroad (1859).

In 1860, at the dawn of the Civil War, branch lines were completed to Cuthbert, Georgia; Fort Gaines, Georgia; and Eufaula, Alabama. After the war, in 1868, the aforementioned Muscogee Railroad (Columbus to Macon) was absorbed by the Southwestern Railroad.

On June 24, 1869, the Southwestern was leased by the Central Railroad. But its expansion continued: Albany to Arlington (thirty-six miles) in 1873, Fort Valley to Perry (twelve miles) in 1875, Arlington to Blakely (thirteen miles) in 1881 and Blakely to Columbia, Alabama (twelve miles), as a bridge is built over the Chattahoochee, in 1889.

In 1879, the SW Railroad became the Southwestern Division of the Central Railroad. In the late 1880s, the Southwestern Railroad

nomenclature disappeared, and the line became identified only as a division of the Central of Georgia.

In 1954, the Central of Georgia Railway purchased most of the outstanding stock of the Southwestern Railroad.

Tallulah Falls Railway

The tale of the Blue Ridge & Atlantic Railroad and the Tallulah Falls Railroad begins with the Northeastern Railroad of Georgia. In 1856, the Northeastern Railroad of Georgia was chartered to run from Athens, Georgia, to Clayton, Georgia. However, no track was laid until after the Civil War. In 1871, the Northeastern Railroad of Georgia began construction northward from Athens to Cornelia. On September 1, 1876, the Northeastern Railroad of Georgia linked with the Atlanta & Richmond Air Line Railway in Lula, Georgia.

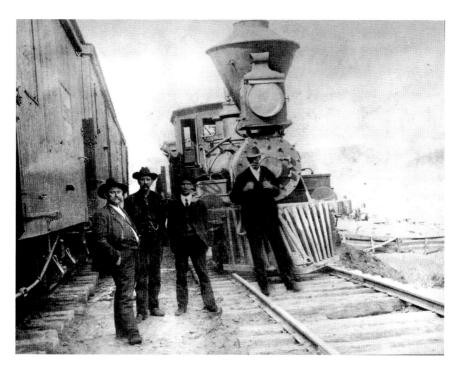

Tallulah Falls Railroad, 1906.

By 1881, financial difficulties precluded further construction north from Lula, Georgia. The Northeastern Railroad of Georgia was then leased to the Richmond & Danville Railroad, owned by Thomas Clyde.

Also in 1881, the Northeastern Railroad of Georgia was granted trackage rights on the Atlanta & Charlotte Air Line Railway (formerly the A&RAL) from Lula to Cornelia (twelve miles).

In 1882, twenty miles of track was laid from Cornelia to Tallulah Falls. Clyde originally had planned to use the Northeastern Railroad of Georgia as the beginning of a line north from Athens to Knoxville, Tennessee, but ultimately abandoned the plan and lost interest in further northern expansion of the road.

In 1887, the Blue Ridge & Atlantic Railroad purchased the unprofitable Cornelia–Tallulah Falls section from a delighted John Inman and the Richmond Terminal Company. One train a day operated on the Blue Ridge & Atlantic Railroad.

In 1892, the Blue Ridge & Atlantic Railroad went into receivership. From 1893 to 1899, the Blue Ridge & Atlantic Railroad was operated by R.K. Reaves, agent of the State of Georgia.

In 1897, new investors rescued the company from receivership and created the Tallulah Falls Railway. And, somewhat astonishingly, by the summer of 1904, track construction was finally completed to Clayton, Georgia.

In 1907, with some financial help from the Southern Railway, the line was extended northward to Franklin, North Carolina. But as Clyde and Inman had predicted, there wasn't enough business to sustain operations, and in 1908, the Tallulah Falls Railway went into receivership, which lasted until the next year.

From 1923 to 1961, the Tallulah Falls Railway operated in receivership. It was finally abandoned in 1961.

One bright spot for the often-bankrupt railroad was that in 1956, Walt Disney Productions filmed *The Great Locomotive Chase* on the Tallulah Falls Railway, as he thought that the terrain looked more like the 1860s terrain of the Western & Atlantic than the Nashville, Chattanooga & St. Louis line looked in 1956.

WRIGHTSVILLE & TENNILLE RAILROAD

The Wrightsville & Tennille Railroad is an interesting example of a modest railroad charter that, through several acquisitions, reached to more than one hundred route miles. It still exists today (as part of Norfolk Southern), and it

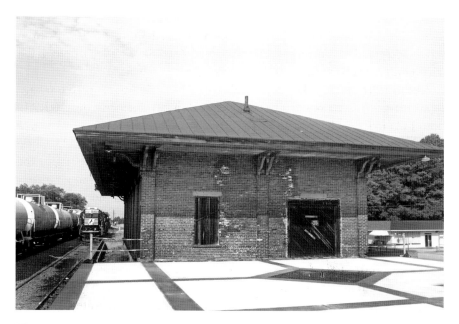

Modern picture of the old Wrightsville & Tennille depot in Tennille. *Photo by Robert C. Jones.*

is still doing the same thing today as when it was originally built: transporting kaolin deposits to market.

Kaolin is a clay-like substance used in many industrial applications, including putting the shine on paper. Georgians who have visited Providence Canyon State Park have seen layered kaolin close up.

The Wrightsville & Tennille Railroad was chartered in 1884 to build a sixteen-mile line from the Central Railroad in Tennille to Wrightsville (south). In order to build the line, financial assistance was provided by the Central Railroad.

In 1886, again with the help of the Central, the W&T absorbed the nineteen-mile Dublin and Wrightsville Railroad, moving it southwest toward Macon. The line was now thirty-five miles long.

In 1891, the Central Railroad helped fund the W&T in building a bridge across the Oconee River, allowing the W&T to enter Dublin (before, the line stopped at the river, northeast of Dublin). The reason for this largesse? The same year, the independent Macon, Dublin & Savannah Railroad completed its Macon–Dublin line.

In 1899, the W&T absorbed the forty-mile Oconee & Western Railroad, which ran from Dublin to Hawkinsville (southeast of Macon). The W&T

was now more than seventy-five miles long. The same year, the W&T was officially purchased by the Central of Georgia Railway.

In 1908, the W&T acquired the Dublin & Southwestern Railroad (twenty-eight miles), between Dublin and Eastman, giving it a total right of way mileage of more than one hundred miles. The branches east and south of Dublin continued to operate until 1941, when they were abandoned.

In 1971, the W&T officially became a branch of the Southern Railway (now Norfolk Southern).

Chapter 4
THE TWENTIETH CENTURY

The Class I Railroads Take Over

By 1900, the railroad system in Georgia had been almost built out, allowing little room for entrepreneurs to build new mainline railroads (although a number of lumber and mining railroads were built that today we would call short lines). Consolidation had already started in the 1890s, and the major players in Georgia railroading in the early twentieth century made up a remarkably small list. One way to measure the size of a railroad is by looking at its gross and net. By 1908, as the following table from the *Statement for Financial Operations of Railroads for the Year Ending June 30, 1908* shows, the big players were already coalescing.

RAILROAD	GROSS EARNINGS	OPERATING EXPENSES	NET EARNINGS
Atlanta & West Point	$1,151,791.07	$916,405.14	$235,385.93
Atlantic Coast Line	$4,616,075.70	$3,398,330.13	$1,217,745.57
Central of Georgia	$8,939,397.56	$6,453,968.44	$2,485,429.12

RAILROAD	GROSS EARNINGS	OPERATING EXPENSES	NET EARNINGS
Georgia Railroad	$2,858,750.36	$2,366,135.84	$492,614.52
Louisville & Nashville	$1,263,778.92	$1,113,925.42	$149,853.50
Seaboard Air Line	$3,522,474.20	$2,825,150.07	$697,324.22
Southern Railway	$6,764,343.15	$5,622,393.66	$1,141,949.66
Western & Atlantic (NC&StL)	$2,664,757.77	$1,975,513.70	$689,243.47

They weren't the only railroads in Georgia, of course. The following list comes from the *Thirty-Fifth Report, Part I of the Railroad Commission of Georgia* (1908):

- Alabama Great Southern Railroad
- Albany & Northern Railway
- Atlanta & Birmingham Air Line Railway (see Seaboard Air Line)
- Atlanta & West Point Railroad
- Atlanta, Birmingham and Atlantic Railroad
- Atlanta, Stone Mountain & Lithonia Railway
- Atlantic Coast Line Railroad
- Augusta & Florida Railway
- Augusta Southern Railroad
- Brinson Railway
- Central of Georgia Railway System
- Charleston & Western Carolina Railway
- Chattanooga Southern Railroad
- Douglas, Augusta & Gulf Railway
- Fitzgerald, Ocilla & Broxton Railroad

- Fitzgerald, Ocmulgee & Red Bluff Railway
- Flint River & Northeastern Railroad
- Florida Central Railroad
- Flovilla & Indian Springs Railway
- Gainesville Midland Railway
- Garbutt & Donovan Short Line Railroad
- Georgia Coast & Piedmont Railroad
- Georgia, Florida & Alabama Railway
- Georgia Granite Railroad
- Georgia Northern Railway
- Georgia Railroad
- Georgia Southern & Florida Railway
- Gulf Line Railway
- Hartwell Railway
- Lawrenceville Branch Railroad
- Lexington Terminal Railroad
- Louisville & Nashville Railroad
- Louisville & Wadley Railroad
- Macon & Birmingham Railway
- Macon, Dublin & Savannah Railroad
- Millen & Southwestern Railroad
- Milltown Air Line
- Register & Glennville Railway
- Sandersville Railroad
- Savannah & Statesboro Railway
- Seaboard Air Line Railway
- Smithonia & Dunlap Railroad
- Southern Railway System
- South Georgia Railway
- Statenville Railway
- St. Marys & Kingsland Railroad
- Sylvania & Girard Railroad
- Talbotton Railroad
- Talulah Falls Railway
- Union Point at White Plains Railroad
- Valdosta Southern Railway
- Wadley Southern Railway
- Western & Atlantic Railroad
- Wrightsville & Tennille Railroad

"Man in railroad station, Manchester, Georgia," May 1938. *Courtesy Library of Congress.*

Once again using our yardstick of one hundred miles of track and/ or strategic importance, we'll now examine railroads that came into prominence in the twentieth century. By the end of the twentieth century, only two had survived.

ATLANTIC & BIRMINGHAM RAILWAY

On October 24, 1887, the logging railroad Waycross Air Line Railway was chartered. It quickly began laying track northward, and by 1890, it had completed the line from Waycross to Sessoms, Georgia (twenty-five miles). By 1901, the WAL was operating seventy-one miles of track, from Waycross to Fitzgerald (via Sessoms and Douglas). Representing greater expectations, the name was changed to the Atlantic & Birmingham Railroad in the same year.

In 1903, the A&B Railroad was complete from Waycross to Montezuma, Georgia (139 miles). Montezuma provided a connection with the Central of Georgia Railway. Also in 1903, the A&B purchased the Tifton & Northeastern Railroad (25 miles) and the Tifton, Thomasville & Gulf Railway (56 miles).

In December 1903, the A&B Railroad was reorganized as the Atlantic & Birmingham *Railway*. This was not because of financial difficulties but rather to accommodate the acquisitions. In 1904, the A&B Railway purchased the Brunswick & Birmingham Railway, giving the A&B access to the port of Brunswick. The A&B would try for several years to make Brunswick a major port but would fail.

In 1906, the A&B Railway was purchased by Atkinson, Arkwright for the Atlanta, Birmingham & Atlantic Railroad. The AB&A didn't skip a beat—the same year, it purchased the Eastern Railway of Alabama (Pyriton to Talladega) and the Alabama Northern Railway (Pyriton to Ashland). Construction west from Montezuma, Georgia, resumed, with Birmingham the ultimate goal.

Meanwhile, also in 1906, the AB&A began expanding the port facilities in Brunswick (spending $1 million in all) and bought a steamship line (Brunswick Steamship Company).

In 1907, the Atlanta, Birmingham & Atlantic Railroad was complete to Pyriton, Alabama (now in the Talladega National Forest), inching ever closer to Birmingham. In 1908, the Atlanta, Birmingham & Atlantic Railroad reached Atlanta to the north and Pelham, Alabama, to the west. Pelham gave the AB&A a connection with the Louisville & Nashville Railroad, which granted it trackage rights to Birmingham. On September 6, 1908, the first through train from Brunswick, Georgia, to Birmingham, Alabama, was run (using the L&N track from Pelham to Birmingham).

In 1909, the AB&A went into receivership, not able to pay the interest on the bonds used to finance the Brunswick port expansion. In 1910, the AB&A completed track from Pelham to Birmingham, Alabama. The AB&A (including the Atlanta branch) now had 645 miles of track, although it was still in receivership. In 1910, the AB&A built a branch line to mines located near Bessemer, Alabama.

In 1915, the AB&A was purchased out of foreclosure by a private investment group, which renamed the railroad the Atlanta, Birmingham & Atlantic *Railway* the next year.

In 1921, the Atlanta, Birmingham & Atlantic Railway defaulted on a $96,000 note and (again) went into receivership. In 1926, the Atlanta, Birmingham & Atlantic Railway was reorganized as the Atlanta, Birmingham & Coast Railroad. It was now under the control of the Atlantic Coast Line Railroad. One of the first things that the ACL did was change the eastern terminus from Brunswick to Jacksonville.

In 1946, the Atlanta, Birmingham & Coast Railroad was officially absorbed by the Atlantic Coast Line Railroad.

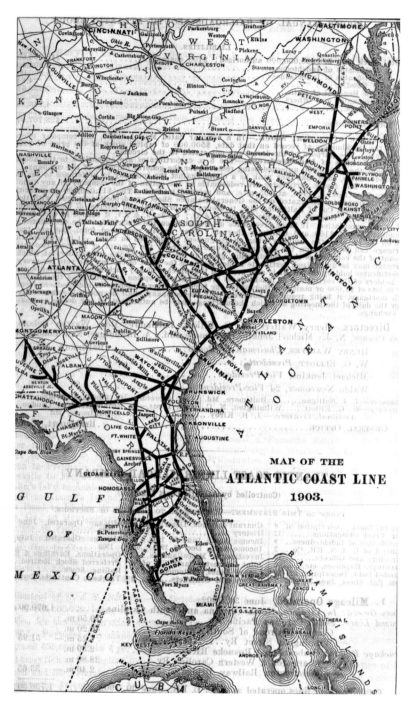

Poor's Atlantic Coast Line Railroad map, 1903.

ATLANTIC COAST LINE

We don't hear much today about the Atlantic Coast Line, but it was a major player in Georgia and other states in the twentieth century. The earliest predecessor is from 1830, when the Petersburg Railroad (Petersburg, Virginia, to Weldon, North Carolina) was founded.

The name Atlantic Coast Line first appears in advertising for the Wilmington & Manchester Railroad and the Wilmington & Weldon Railroad in 1871. But it wasn't actually the official company name until 1897–98, when railroads owned by William Walters in South Carolina were consolidated as the Atlantic Coast Line Railroad Company of South Carolina. Similar consolidation occurred in Virginia with the Atlantic Coast Line Railroad Company of Virginia (1898) and railroads in North Carolina with the Atlantic Coast Line Railroad Company of North Carolina. Finally, in 1900, all of the lines consolidated as the Atlantic Coast Line Railroad Company, under the merged Petersburg Railroad and the Richmond & Petersburg Railroad.

In 1902, the Atlantic Coast Line acquired a controlling interest in the L&N, thereafter controlling the Georgia Railroad, the A&WP and the Western Railroad of Alabama. The same year, the ACL acquired the Plant System in south Georgia and Florida. (The Plant System in 1899 had two thousand miles of track.) The ACL was now a major player in Georgia.

A 1948 photo of a 0-6-0 switch engine in southern Georgia. The locomotive was built by Baldwin in 1904. *Courtesy of Southern Museum Archives & Library, from the collection of David W. Salter.*

A 1948 photo of a 2-8-2 type, Class M-2 locomotive coming into Atlanta, Georgia. *Courtesy of Southern Museum Archives & Library, from the collection of David W. Salter.*

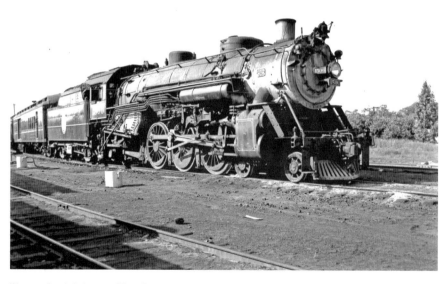

Photo of a 4-6-2 type, Class P-5-A locomotive at Bellwood Yards, Atlanta, Georgia, on June 7, 1947. *Courtesy of Southern Museum Archives & Library, from the collection of David W. Salter.*

By 1925, ACL had 4,924 miles of right of way. The investment in Georgia railroading expanded in 1927 when the ACL purchased the Atlanta, Birmingham & Coast Railroad.

Like other large railroads, the ACL had well-known named trains. From 1928 to 1957, the Southland ran from Chicago to Jacksonville through Macon, Albany and Thomasville. From 1939 to 1979, the Champion streamliner ran from New York to Miami via Savannah (on Amtrak, from 1971 to 1979).

World War II provided boom years for the ACL. Passenger traffic increased 200 percent and freight traffic 150 percent. In 1942, Champion McDowell Davis became president and began a long-term plant and equipment upgrade.

On July 1, 1967, ACL merged with the Seaboard Air Line Railroad, creating the Seaboard Coast Line. In the early 1970s, SCL merged with the Louisville & Nashville Railroad and the Clinchfield Railroad and operated under the marketing name the Family Lines System. In 1983, Family Lines purchased the railroad part of the Georgia Railroad and Banking Company.

In 1986, CSX Transportation was formed when Seaboard Coast Line merged with the Chessie System.

GEORGIA & FLORIDA RAILWAY

In 1903, John Skelton Williams was forced out as president of the Seaboard Air Line by Thomas Fortune Ryan and other financiers in New York City. He never regained control of the vast railroad that he had created.

Williams decided to create a new railroad out of disparate parts to compete with the railroad he himself had built, the Seaboard Air Line. In 1907, Williams created the Georgia & Florida Railway.

The period from 1907 to 1910 was one of great activity for the infant Georgia & Florida. First, Williams made four acquisitions of railroads that did not connect to one another, anywhere: Augusta & Florida Railway, Keysville (southeast of Augusta) to Midville, Georgia, thirty miles; Millen & Southwestern Railway, Millen to Vidalia, fifty-three miles; Douglas, Augusta & Gulf Railway, Barrows Bluff to Douglas, Georgia, twenty-three miles; and Valdosta Southern Railway, Valdosta, Georgia, to Madison, Florida, twenty-seven miles.

Williams then built 85 miles of connecting track, giving the G&F Railway a 250-mile mainline between Augusta, Georgia, and Madison, Florida. In

1911, Williams purchased the Sparks-Western Railroad (Sparks, Georgia, to Moultrie, Georgia, 25 miles).

In 1913, Williams left the Georgia & Florida Railway to become assistant secretary of the United States Treasury. He would remain in government positions until his death in 1926.

In 1915, the G&F Railway went into receivership. Whether this is because the railroad had lost its founder and guiding light or because the times were against a new railroad not owned by a conglomerate is unknown.

In 1919, the G&F acquired the Augusta Southern (Augusta to Sandersville, fifty-three miles) and leased the Midland Railway in 1924. The latter gave the G&F access to Statesboro, Georgia. In 1926, the G&F Railway was renamed the Georgia & Florida Railroad.

As a last hurrah in its expansion plans, from 1927 to 1929 the G&F added an Augusta–Greenwood, South Carolina branch. This gave the G&F a connection with the Seaboard Air Line and the Piedmont & Northern.

After a series of abandonments in the ensuing decades, in 1963 the G&F was acquired by the Southern Railway. In 1971, it was integrated into the Central of Georgia by Southern Railway.

The day of independent mainline railroads was pretty much gone by the early part of the twentieth century.

GEORGIA, FLORIDA & ALABAMA RAILWAY

In 1895, the Georgia Pine Railway was chartered by John P. Williams of Savannah to build from Bainbridge north. By 1898, thirty miles of track had been completed from West Bainbridge (west side of the Flint River) to Damascus, Georgia. In 1901, the GP Railway reached Arlington and a connection with the Central of Georgia Railway. The same year, the name of the railroad was changed to Georgia, Florida & Alabama Railway, perhaps indicating greater ambitions than that of the original Georgia Pine Railway. The Georgia, Florida & Alabama Railway was sometimes referred to as the "Sumatra Leaf Route" after a type of tobacco that was grown in the area.

In 1902, the line was expanded north toward Cuthbert and south toward Tallahassee. In Tallahassee, a connection was made with the Seaboard Air Line Railway.

In 1906, Williams bought the Carrabelle, Tallahassee & Georgia Railroad (Carrabelle to Tallahassee) and merged it with the Georgia, Florida &

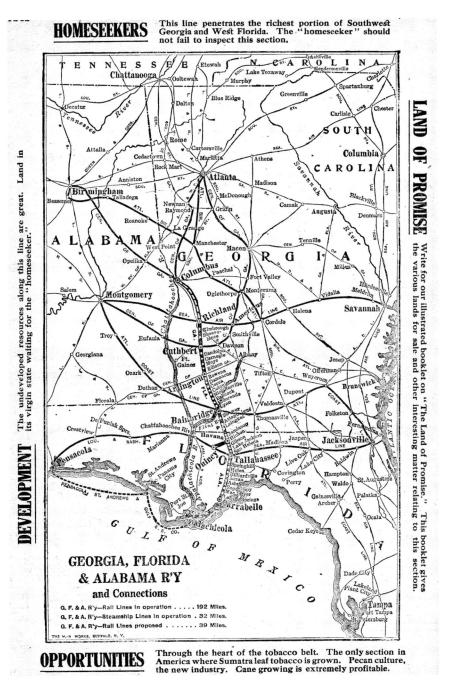

A 1918 map of the Georgia, Florida & Alabama Railway.

Alabama Railway. Carrabelle provided access to a port on the Gulf. The same year, Williams built a Havana–Quincy branch (eleven miles) in Florida (just north of Tallahassee).

By 1910, the Georgia, Florida & Alabama Railway had been extended north to Richland (twenty-seven miles). Richland was a connection point with multiple lines of the Seaboard Air Line Railway. Also in 1910, the GF&A built a bridge across the Flint River to Bainbridge (from West Bainbridge), giving it a connection with the Atlantic Coast Line Railroad.

All told, the Georgia, Florida & Alabama Railway was well run, in solid financial shape and (as mentioned) well connected with more than one major railroad.

John P. Williams died in 1910, and his wife, Cora Williams, took over as president of the Georgia, Florida & Alabama Railway. She remained in this position until 1928, when she sold her GF&A stock to the Seaboard Air Line Railway. Soon, the GF&A was absorbed into the SAL.

Louisville & Nashville

The Louisville & Nashville, known as the "Old Reliable," was chartered by the Commonwealth of Kentucky in 1850. It holds the distinction of operating under its own name (although not its own ownership) for 132 years.

By 1859, track had been completed from Louisville to Nashville just in time for the Civil War. The L&N profited from haulage contracts with Federal forces in Union-occupied Kentucky. After the Civil War, the L&N helped establish Birmingham to encourage development of the rich coal deposits there (and, later, iron deposits).

In 1880, the Louisville & Nashville purchased a controlling interest (55 percent) in the Nashville, Chattanooga & St. Louis Railway. The NC&StL operated the old Western & Atlantic under lease from the State of Georgia.

On May 18, 1881, Colonel Wadley of the Central Railroad assigned 50 percent of the Georgia Railroad lease that he himself had purchased to the Louisville & Nashville Railroad. This gave the L&N an important foothold into the Georgia railroad scene.

By 1884, the L&N had become profitable enough to be listed on the Dow Jones Transportation Average soon after the average was created.

Showing a further commitment to Georgia railroading, in February 1898 the L&N bought the 50 percent share of the Georgia Railroad lease owned by the Central of Georgia Railway (now owned by investment firm

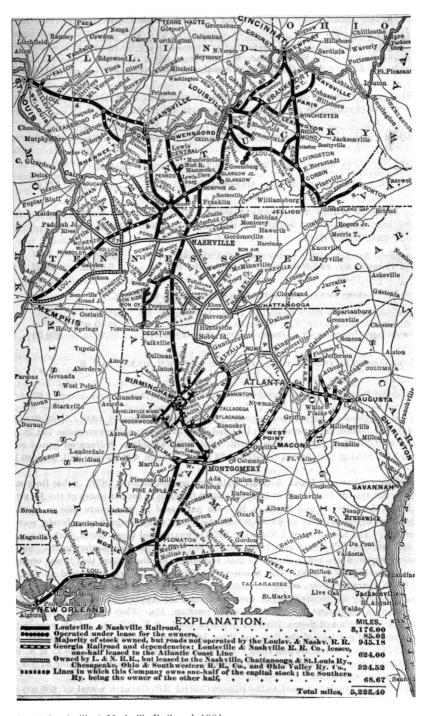

Poor's Louisville & Nashville Railroad, 1901.

Thomas & Ryan). The L&N now controlled the Georgia Railway, the Western Railway of Alabama and the Atlanta & West Point (the last two comprising the West Point Route). And, of course, it controlled the old Western & Atlantic through its control of the NC&StL Railway.

In 1902, thanks to machinations by J.P. Morgan, the Atlantic Coast Line Railroad acquired a controlling interest in the L&N. The L&N, though, continued to operate as a separate company, keeping its own name.

Also in 1902, the L&N acquired the Atlanta, Knoxville & Northern Railway, which ran between Marietta, Georgia, and Etowah, Tennessee. This route was sometimes referred to as the "Hook and Eye Line." The "Hook" part was a double reverse curve between Whitestone and Talking Rock.

In 1946, the L&N Georgian passenger service debuted, running from St. Louis to Atlanta. In 1948, Georgian passenger service started between Chicago and Atlanta.

In 1957, the NC&StL was absorbed into the Louisville & Nashville Railroad (which was controlled by the Atlantic Coast Line Railroad).

By 1970, the L&N was operating 6,063 miles of right of way, making it one of the largest railroads in the United States. In 1971, through stock purchase, the Seaboard Coast Line Railroad (the merged Seaboard Air Line/Atlantic Coast Line Railroad) made the L&N a subsidiary. Shortly after, the SCL merged with the Clinchfield Railroad and was briefly called the Family Lines System.

Like most other East Coast railroads, on May 1, 1971, Amtrak took over L&N passenger service.

In 1983, the Family Lines purchased the railroad part of the Georgia Railroad and Banking Company.

In 1986, all of the aforementioned railroads became CSX Transportation when Seaboard Coast Line merged with the Chessie System.

Savannah & Atlanta Railway

In 1906, George Matthew Brinson and the Imbrie Company chartered the Brinson Railway (Savannah to Sylvania, sixty miles). Brinson was appointed president of the new line.

By 1909, the Brinson Railway had laid forty-three miles of track from Savannah to Newington, where the BRR connected with the Savannah Valley Railroad of Georgia. The SV Railroad already had track in operation from Newington to Sylvania. In the same year, the Imbrie

Company purchased the Savannah Valley Railroad of Georgia, obviating the need to build track from Newington to Sylvania.

By 1914, Brinson had left the railroad named after him, and the Brinson Railway was renamed Savanah & Northwestern Railway by the Imbrie group. This name change reflected a new goal for the northern terminus of the line: Atlanta.

By 1917, the Savanah & Northwestern Railway track had been completed (Savannah to Camak, 142 miles), where it hooked up with the Georgia Railroad. This began a long-term and close relationship between the two railroads. Also in 1917, the Savannah & Northwestern Railway was renamed the Savannah & Atlanta Railway. This not only provided the shortest route (by 28 miles) between Atlanta and Savannah but also gave the Georgia Railroad its only entrance into Savannah itself.

In 1921, the Savannah & Atlanta Railway entered into receivership. It would remain there until 1929, when the S&A was purchased by Central of Georgia. It eventually was absorbed into the Southern Railway and then Norfolk Southern.

SOUTHERN RAILWAY

"The Southern Serves the South—Look Ahead, Look South"

In the old days (mid-nineteenth century), railroads were formed when a group of investors put up some money and hired people to go out and lay track. But the railroad possibly most ubiquitous in Georgia railroading circles in the twentieth century was created when one man, John Pierpont Morgan, shuffled around several existing railroads like pieces on a chess board and produced the Southern Railway in 1894.

Southern Railway map, 1921.

Some estimates figure that the Southern Railway had 150 predecessor railroads. The oldest railroad that can be traced in the Southern Railway heritage is the South Carolina Canal and Rail Road Company, which on December 25, 1830, began running passenger service on a six-mile section of track out of Charleston, South Carolina, pulled by the locomotive Best Friend of Charleston.

By 1891, though, the South Carolina Canal and Rail Road Company was long forgotten. But the financial fortunes of the Richmond Terminal Company and the various railroads that it controlled looked increasingly grim. Much of the equipment and infrastructure on the railroads was poor. There was way too much debt (see, for example, the 1901 *History of the Legal Development of the Railroad System of Southern Railway*) caused as acquisitions continued to be made, even though current properties weren't producing. And creative bookkeeping on the part of the Richmond & Danville (which had operated at a loss in 1890, but this had been hidden by phony entries in the books) was starting to attract attention of stockholders and others.

A committee headed by Frederic P. Olcott of New York worked out a plan for reorganization, but those opposed kept it from happening in a timely fashion. When the financial Panic of 1893 hit, the RTC went into receivership. (Of course, this is a bit of a chicken-and-the-egg situation. Did the financial panic cause the RTC to go into receivership, or were the financial problems of the RTC one of the reasons for the financial panic?)

In 1893, financier J.P. Morgan was coaxed into reorganizing the railroads under the RTC. In 1894, the Southern Railway was born. It encompassed the Memphis & Charleston Railroad, the Richmond & Danville system and the East Tennessee, Virginia & Georgia Railroad. It boasted 4,800 miles of right of way, making it one of the largest railroads in the South out of the box.

As the following excerpt from the 1921 work *The Railroad Builders* by John Moody indicates, there were losers as the result of Morgan's grand reorganization. But the railroads experienced an almost immediate upgrade of infrastructure:

> *The plan of reorganization whereby this great aggregation of loosely controlled and poorly managed Southern railroads was welded together into an efficient whole was a very drastic one in its effect on the old security holders. Debts were slashed down everywhere, assessments were levied, and old worthless stock issues were wiped out. Valueless sections of mileage were lopped off, and an effort was immediately made to strengthen those of*

real or promising value. Millions of dollars of new capital were spent in rebuilding the main lines; terminals of adequate scope were constructed in all centers of population; and alliances were made with connecting links with a view to building up through traffic from the North and the West.

In October 1894, the first shareholders meeting of the Southern Railway was held and a board elected (with three Morgan appointees included), with Samuel Spencer as president. Spencer would go on to build new shops in Atlanta, Georgia.

Almost immediately after its creation, the Southern Railway began a vigorous expansion program through acquisition and leasing, acquiring controlling interest in the Georgia Southern & Florida and the Alabama

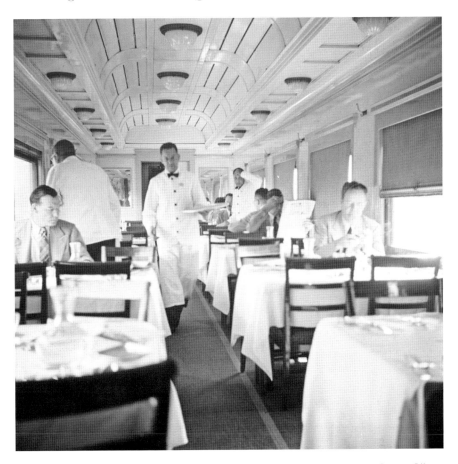

"Southern Railway dining car, 8 a.m., somewhere in Georgia," August 1941. *Courtesy Library of Congress.*

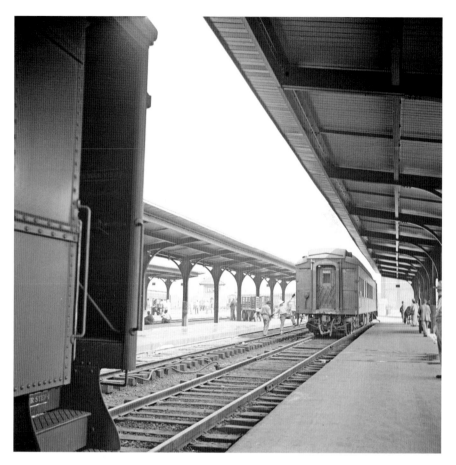

"Hitching on a new section. The Southern Railway, Atlanta, Georgia," August 1941. *Courtesy Library of Congress.*

Opposite, top: "Southern R.R. Co. Crescent Locomotive," circa 1916. *Courtesy Library of Congress.*

Opposite, bottom: "'The Crescent.' Rear view showing PS Observation Car from Lenox Road overpass, Atlanta, Georgia in July, 1950." *Courtesy of Southern Museum Archives & Library, from the collection of David W. Salter.*

Great Southern in 1894, acquiring the Asheville & Spartanburg Railroad in 1895, leasing the Georgia Midland Railway (one hundred miles) in 1896 and acquiring the South Carolina & Georgia and the Augusta Southern railroads in 1899. By 1916, the Southern Railway directly controlled eight thousand miles of right of way in thirteen states.

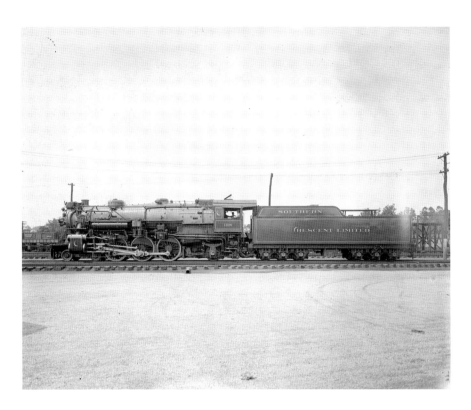

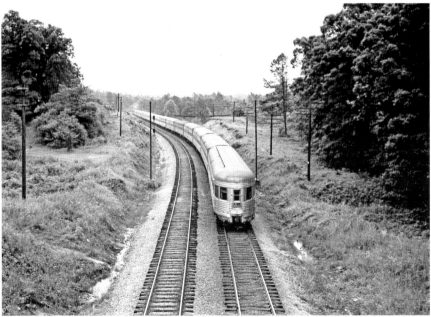

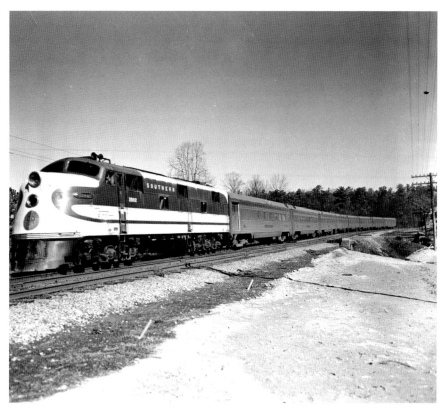

"Southern's south bound 'Southerner'...at Armour, Atlanta, Georgia on March 22, 1947."
Courtesy of Southern Museum Archives & Library, from the collection of David W. Salter.

As the railroad business consolidated into a small number of large players in the early part of the twentieth century, named trains, running on multiple right of ways, became more common. For example, from 1899 to 1976, the Southern railway Piedmont Limited operated from New York to New Orleans via Atlanta. In 1925, the Southern Crescent Limited ran from New York to New Orleans through Atlanta (in 1938, the Crescent Limited became simply the Crescent). I've ridden on the Amtrak version of the Crescent many times, from Atlanta to Thirtieth Street Station in Philadelphia.

In the 1950s and 1960s, a new spate of acquisitions occurred, the most notable being the Central of Georgia Railway in 1963. On June 17, 1963, the St. Louis–San Francisco Railway sold its stock in the Central of Georgia Railway to the Southern Railway. In an interview, Dan Berman discussed the acquisition of the venerable Central of Georgia railroad:

"Southern EMD Switcher No. 2261 at Inman Yards in Atlanta, Georgia on February 29, 1948." *Courtesy of Southern Museum Archives & Library, from the collection of David W. Salter.*

They had a lot of industry on that railroad. But they didn't have a lot of cars. Their equipment was old, they had 54, or 68 cabooses, and they were all the old wooden cupola type, built out of 36' boxcars. So, we bought the Central of Georgia for $27,000,000....We got a lot of business from the Central of Georgia because they had a lot of originating traffic on the Central, but didn't have the cars to supply it.

Other acquisitions included the Live Oak, Perry & Gulf Railroad and the South Georgia Railway in 1954; the Georgia & Florida Railroad (the G&F was merged into the Central in 1971) in 1963; the Georgia Northern and the Albany & Northern in 1966; and the Tennessee, Alabama & Georgia Railway in 1971.

In 1971, the Southern Railway merged the Central of Georgia Railroad with the Savannah & Atlanta Railway and the Wrightsville & Tennille Railroad. It retained the name of Central of Georgia Railway with the newly merged railroads.

The Southern Railway was known for its innovation. As early as 1940, Southern had ordered MD E6s and Alco DL-109s (diesels). By 1953, the

Inman Yards, Atlanta, after 1968. *Courtesy Library of Congress.*

Southern Railway passenger car at the Southeastern Railroad Museum. *Photo by Robert C. Jones.*

company had eased out all its steam locomotives, the first major railroad in the United States to do so. It was also one of the first railroads to utilize computers, as well as unit coal trains and Centralized Traffic Control (CTC).

The Southern Railway held on to its passenger service longer than most Class 1 railroads, which had bailed out their passenger service to Amtrak in 1971. Finally, on February 1, 1979, Southern turned over its passenger business (including the Southern Crescent) to Amtrak. Dan Berman commented:

> *And I don't know if you know this, but when you join Amtrak, you had to pay to join Amtrak. And they would buy whatever cars from you that met their requirements. We had a lot of pretty old—streamline cars—but still pretty old. But we just decided not to join in '71. The reason we joined in '78, Stanley Crane was president, we had a bad derailment at Lynchburg* [Virginia], *and six people were killed. And he said, "We can't handle this, we're going with Amtrak."*

In 1980, the Norfolk & Western and Southern Railway formed the Norfolk Southern Corporation.

In the early 2000s, a former Southern Railway loop was acquired by the City of Atlanta and became the Beltline trail.

SEABOARD COAST LINE/SEABOARD AIR LINE RAILROAD

Known as the "Route of Courteous Service," the Seaboard (in its several different manifestations) was one of the largest railroads on the eastern seaboard in the twentieth century.

Its earliest known predecessor was probably the Portsmouth & Roanoke Railroad, which was chartered by Virginia and North Carolina on March 8, 1832. The name Seaboard first appears in 1846, when the Portsmouth & Roanoke Railroad became the Seaboard & Roanoke Railroad.

As early as 1881, the "Seaboard Air Line" nomenclature was being used as the Seaboard & Roanoke and the Raleigh & Gaston started operating under the marketing name Seaboard Air-Line System.

In 1895, predecessors of the Seaboard Air Line Railway purchased the Savannah, Americus & Montgomery Railway, giving them a competitive foothold against the Central Railroad.

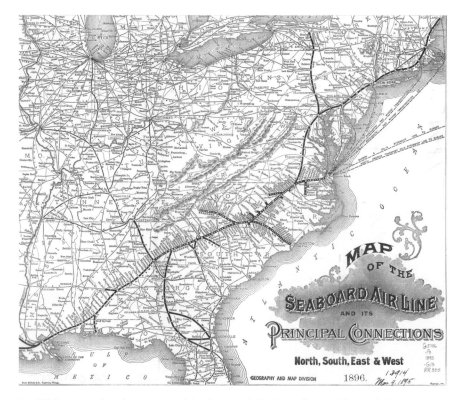

An 1896 map (before the merger) of the Seaboard Air Line. *Courtesy Library of Congress.*

In 1889, the Seaboard leased the Georgia, Carolina & Northern Railway, giving it access to Atlanta in 1892. From 1898 to 1900, an all-Seaboard route from Atlanta to Richmond via affiliate Richmond, Petersburg & Carolina was in operation.

In 1899, the Seaboard Air Line Railway was created with a merger of Florida Central & Peninsular Railroad, the Seaboard Air Line and the Georgia & Alabama Railroad. One can easily see that from 1895 to 1900, the Seaboard Air Line Railway had gotten pretty serious about railroading in the state of Georgia.

By April 14, 1900, the Seaboard Air Line Railway was made up of nineteen railroads, with John Skelton Williams named as president. On June 3, 1900, service from New York to Tampa, Florida, began via Savannah.

The Seaboard Air Line wasn't done with acquisitions, including acquisitions in Georgia. On July 1, 1900, the SAL assumed operation of the Georgia & Alabama Railroad, the Florida, Central & Peninsular Railroad and the Atlantic, Suwanee River & Gulf.

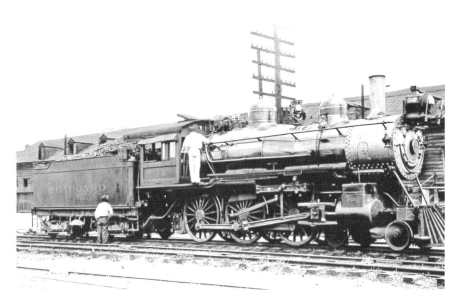

"Steam Engine No. 34 at Savannah, Georgia in May, 1916." *Courtesy of Southern Museum Archives & Library, from the collection of David W. Salter.*

Showing that the Seaboard Air Line Railway was not limited to the coastal areas of Georgia, in 1901 the Atlanta Special began operations from North Carolina to Atlanta. In 1904, the Atlanta route was extended to Birmingham via subsidiary Atlanta & Birmingham Air Line Railway. Also that year, Thomas Fortune Ryan assumed control of the Seaboard Air Line Railway from John Skelton Williams (Williams was somewhat unceremoniously booted out of his position).

Although on paper the Seaboard Air Line Railway looked like a profitable set of routes, it went into receivership in 1907 and Ryan was removed. In 1912, S. Davies Warfield assumed majority stock ownership after acting as the receiver (no potential conflict of interest there).

From December 28, 1917, to March 1, 1920, the Seaboard Air Line Railway operated under the United States Railroad Administration. After World War I ended, control eventually returned to the SAL (as it did to other railroads).

The most famous train of the Seaboard Air Line Railway was the Orange Blossom Special (turned into a song by Johnny Cash and others). The Special operated from November 21, 1925, to April 26, 1953, running from New York to Tampa/St. Petersburg (and eventually Miami) via Savannah.

Engine No. 221, a Class "M1" Mountain, in the late 1940s. *Courtesy of Southern Museum Archives & Library, from the collection of David W. Salter.*

In December 1930, Seaboard Air Line Railway entered bankruptcy again, this time because of the collapse of Florida land prices. (They had real estate speculation in the 1920s not unlike the speculation in the early twenty-first century that led to the Great Recession.) Legh R. Powell was appointed receiver.

On February 2, 1939, the highly profitable Silver Meteor service began between New York and Miami, passing through Savannah and Jesup.

At the end of World War II, Seaboard Air Line Railway went belly up. In May 1945, its properties were sold at auction for $52 million to bondholders. The reorganized railroad was now called the Seaboard Air Line *Railroad*.

From May 18, 1947, to June 1969, the Silver Comet ran from New York to Atlanta and Birmingham. People who live in the Atlanta area may be familiar with the Silver Comet Trail, which uses old railroad roadbed.

On July 1, 1967, the Atlantic Coast Line Railroad merged with the Seaboard Air Line Railroad to form the Seaboard Coast Line Railroad (SCL), which also added the old Western & Atlantic to the fold.

On May 1, 1971, Amtrak took over the passenger service of the Seaboard Coast Line Railroad. In 1972, Seaboard Coast Line, Louisville

& Nashville, Georgia Railroad, West Point Route and the Clinchfield Railroad began referring to themselves as the Family Lines System. This term faded into obscurity on December 29, 1982, when the combined railroads were renamed the Seaboard System.

In 1983, the Seaboard System purchased the railroad part of the Georgia Railroad and Banking Company. In 1986, the Seaboard System and the Chessie System merged to create CSX.

TWENTY-FIRST-CENTURY
RAILROADS IN GEORGIA

Railroading is certainly different today than it was in years past. Seven Class I railroads (two of them in Georgia) control the vast amount of railroad shipping in the United States: BNSF, Canadian Northern, Canadian Pacific, CSX Transportation, Kansas City Southern, Norfolk Southern and Union Pacific. With the integration and consolidation of railroading in the United States, great efficiencies have resulted. However, Dan Berman feels that with the loss of competition has come a loss of innovation:

> *At the time that I retired, railroading was going in a worse direction. There were way too many mergers, and it cut down on the amount of competition. When I first came to work for Southern in '61, there was a lot of competition, especially between the Southern and the SCL [Seaboard Coast Line], and a lot of competition between other railroads. When the railroads out West merged, all into the UP and all into the BNSF, the competition dried up. So, if a railroad doesn't have competition, they do whatever they can get by with. If they have competition, they'll be innovative in order to get business. They'll out-compete the other guy.*

However, there is another side to the question. Craig Bicknell commented on the consolidation of eastern Class I railroads from three to two:

> *The bottom line was, there really wasn't enough business to have three [NS, CSX and Conrail] strong railroads in the eastern half of the country.*

Particularly considering that the eastern half of the country is so truck competitive…. Truck competition, they're a huge competitor to railroads. Even though railroads compete with each other, somewhere between 85 and 90 percent of inter-city tonnage moves via truck, and only 10 to 15 percent moves via rail.

If we had stayed with three railroads in the East, all three would have been weaker and less able to provide the innovative services and changes to their services than two stronger companies are.

John Marbury offered similar observations:

From a business standpoint, it is probably a good thing; healthy for the businesses. They've taken about all the savings they can get by consolidating with the smaller railroads, and yet they've left competition still there, so there is a reason to be negotiating rates, because you've got competition. And that's good. I don't think we need anything fewer than that. From the standpoint of the rail fan, I miss the fallen flags; I wish they were still around. But the truth be known, it's probably made the business a lot healthier than if it hadn't happened. I think the system of two in the East is as far as you'd want to go, you've got competition, and I think that two would be healthier than three or four.

I also received interesting comments from Craig Bicknell on how much the Class I railroads actually compete with one another:

Railroads are competitors, but we are also partners. In order to get your goods from point A to point B, over 40 percent of the time, your lading is going to involve at least two railroads and sometimes four or five. So, that handoff we have to another railroad, whether it be CSX, or BNSF or UP, or any of the myriad short lines that we operate with, we're actually partnering with them. We want that load to get there on time. And we need to do our part, and you need to do your part, together. We interchange maybe $400,000,000, $500,000,000 worth of goods or transportation services with Canadian Pacific. And we competed on maybe, what, a $100,000,000? So, we're a partner a lot more than a competitor.

Pete Silcox added this:

Railroads are partners when they gather up against government or regulations, but when it comes down to business, we're adversaries of

each other, all the time. We fight tooth and nail over getting business, but whenever there is a new regulation coming out, the railroads all get together again: "Oh, no, we don't like that." We kind of bounce back and forth in a working friendship.

One of the questions that I asked my panel of retired railroad executives was, "How is railroading different in the twenty-first century from the twentieth century?" Some people, such as Craig Bicknell, responded with changes in technologies:

One of the biggest innovations that we have gone to is locomotive-assisted computerization. We called it LEADER [Locomotive Engineer Assist Display and Event Recorder]. It's a program that helps the engineer determine exactly how much power to apply to the locomotive every mile along his route. It is actually pre-mapped with geography, as well as knowledge of the trailing tonnage that you have, so that it optimizes the RPMs, throttle settings all along the route, minimizing fuel use. And also minimizing train mishandling....That's been a huge savings. Norfolk Southern worked with GE to develop that.

...Another thing that Norfolk Southern did...one of the most challenging jobs in the industry is to keep up with all the activity that is going on at the local level....We came up with a remote device [Remote Intelligence Terminal (RIT)], like a glorified smart phone, or tablet, that you can plug the car into any activity that you have—you're leaving the yard with a car, you have a consist of cars on your train, and you push a button, and instantly, all your computer systems are updated. Is it on the move, has it arrived and, also, when you've given it to the customer, you bring up the car list, punch a couple of buttons—placed, picked up. All that activity within minutes of it actually taking place. The conductor can now instantaneously update the status and location of every freight car on that train.

But another change in the twenty-first century has nothing to do with technology, but rather a rapid transition to a younger workforce and different styles of management. Standardization was another important change, as Craig Bicknell noted:

When I started at Norfolk Southern, in 1998, and in early 2000, 55 percent of Norfolk Southern's management, and possibly as much as 60 percent of Norfolk Southern's union force, were age fifty and over. The

bringing on of a younger workforce has created some unique challenges for us because today's young person is looking for something different than people in generations past. You can't rule with an iron fist anymore. You can't just tell somebody to go do something and expect them to do it. You have to explain to them why it is a good idea. And not only that, but be open to criticism of what you want them to do or suggested changes. And they can be female—we didn't have very many females before. So we really had to revamp our entire view of railroading. But not only that. A lot of people that come out of high school or college really have no idea what railroading is all about. Our grandparents and our parents knew—they could just turn on the radio and hear five railroad songs.

Pete Silcox added:

Management, and the way we managed the railroad, was different. We used to have all these individual little railroad companies all doing their own thing basically, to come into one big organization, buy one type of locomotive, one type of boxcar. We got more uniform in our purchases of equipment. It became more of a system than an individual railroad doing its own thing. That is a big change, and the attitude of management in getting along with the unions changed a lot. We have a lot better relationship and a lot less hostility by far. We got a lot more innovative, a lot less stymied in the "we've always done it that way" attitude.

We got a lot more diversified. I had a couple of assistants that worked with me that were female, which was really unusual before in the railroad.

The coming of computers has revolutionized railroading. John Marbury provided one example:

So much of our relay [signal] *logic has been replaced by software logic, which is not as susceptible to things like rat droppings and things like that. Sometimes, you'd go into some real foul signal boxes which had been invaded by rats, and they've built a nest in there. And they'd be around where the wires were because they like the warmth. Plus, they chew on the insulation for some reason. We've still got wires, but it is a lot different today—not as many wires.*

And Pete Silcox provided another:

We developed a computerized system to inspect track. Prior to that, everything was a paper report, and it got to be quite voluminous to keep up with. It took us three years to develop a totally new computer program to keep up with it. We got everybody a small laptop, and everybody went out and starting inspecting track and recording it....It's still being used.

Construction techniques have changed radically in recent decades, as John Marbury, who spent sixteen years as a construction manager for Norfolk Southern, can attest:

One big change is with the construction stuff, where you used to almost build stuff from scratch, with poured foundations. Now everything is prefabricated, even the foundations. They come in and handle them with cranes. It cut back on a lot of the labor that we used to do in the field when we installed stuff.

In 2016, there were two Class I freight railroads operating in Georgia—Norfolk Southern and CSX—and twenty-nine short lines. Of the short lines, all of them are Class III, and twelve are owned by Genesee & Wyoming (G&W). Route mileage in Georgia can be seen in the following table, created from data provided by the Georgia Department of Transportation website (dot.ga.gov).

ROUTE MILEAGE IN GEORGIA

Railroad	*Miles Owned*	*Percent*	*Miles Operated*	*Percent*
CSX Transportation	1,449	31	1,614	34
Norfolk Southern	2,064	44	1,721	37
Short Lines	522	11	1,362	29
Georgia DOT	490	11	0	0
Georgia State Properties Commission (W&A)	118	3	0	
TOTAL:	4,643	100	4,697	100

Link: http://www.dot.ga.gov/InvestSmart/Rail/Documents/StateRailPlan/2015GeorgiaStateRail Plan-1-26-16.pdf.

In addition to the railroads mentioned in the table, heavy rail commuter service exists in the Atlanta area (MARTA), and Atlanta also has a short-haul streetcar system (Atlanta Streetcar). Four tourist railroads operate in Georgia, one operated by the state (SAMS Shortline), and Amtrak operates four trains that have stops in the state.

CSX

CSX, one of the two freight colossi in Georgia, was founded on July 1, 1986, when the Chessie System and Seaboard System combined, forming a Class I railroad with about twenty-one thousand track miles. The Chessie System included the Chesapeake & Ohio Railway, Baltimore & Ohio Railroad and Western Maryland Railroad. The Seaboard included the Atlantic Coast Line Railroad, Louisville & Nashville Railroad, Clinchfield Railroad, Atlanta & West Point Railroad, Monon Railroad and Georgia Railroad. Pete Silcox (now retired) was working for Seaboard Coast Line when the merger came. He commented on what he observed:

CSX freight train trundles though Kennesaw, Georgia, in the 1990s. *Photo by Robert C. Jones.*

You always have the people who bemoan the fact that they started with the Atlantic Coast Line, or they started with Seaboard Air Line or they started with Georgia Railroad, and they'd have their belt buckles and they'd have their jackets. They'd be all about "the way we used to do it." Well, it doesn't matter how we used to do it. Times change, and here's what we do now. They didn't like the color of the locomotives. As long as you get paid, you do your job, you go with their decisions. If you get to be executive director of the railroad, you can decide what color to paint the engines.

On June 1, 1999, CSX got larger—Conrail (composed of the ruins of railroads such as the PRR, New York Central, Lehigh Valley, Reading, Erie Lackawanna and so on) was taken over by CSX and Norfolk Southern.

As of 2014, operations of CSX in Georgia include operating and maintaining nearly 2,700 miles of track, maintaining more than 2,020 public and private grade crossings and handling more than 1.9 million carloads of freight on the state's rail network. At the end of 2014, CSX employed nearly 3,200 people. Throughout 2014, CSX reported more than $255.1 million in compensation for employees.

In 2014, CSX invested more than $129.5 million in its Georgia network. In addition, the company invested nearly $539 million in freight cars and other rolling assets to serve customers through its rail system.

CSX carries a variety of commodities important to our economy and way of life, including consumer products, automobiles, food and agriculture products, coal and chemicals. Primary commodities produced or consumed within the state include containerized consumer goods, aggregates, coal, feed grain and light trucks. CSX maintains major rail yards at Waycross (Rice), Atlanta (Tilford) and east Savannah. (This information and more can be found at https://www.csx.com/index.cfm/about-us/state-information/georgia.)

The challenges that CSX faces are similar to those of other Class I railroads. Pete Silcox noted:

The economy is still struggling right now. Business is down overall about 15 percent; of course coal is the big loser—it's off about 30 percent for CSX. Everything is off except grain, which is seasonal. And the ferrous and scrap metal is picking up a little bit. And the general, miscellaneous, catch-all commodities are up a little bit. But the big losers are coal, crude oil and building materials and sand and gravel. With those down, that means

that the building industry is down. The economy in the country affects the
railroads almost immediately.

NORFOLK SOUTHERN

Norfolk Southern was incorporated in 1980, and in 1982, Norfolk Western and Southern Railway were consolidated within Norfolk Southern. The consolidation made Norfolk Southern the fourth-largest railroad in the country in terms of track (about seventeen thousand miles of right of way). At the time of the consolidation, both Southern and Norfolk Western were profitable companies—this was not a merger of bankrupt companies (e.g., Penn-Central). It was a joining of successful titans.

Dan Berman offered his perspective on why the merger actually occurred:

The UP [Union Pacific] *and the BNSF* [Burlington Northern Santa Fe] *were making overtures—just like the CP has done lately—to buy the Southern....A lot of our presidents since after the Civil War had graduated from VMI. The N&W had a lot of VMI graduates, and they had a lot of VMI money. So the N&W made overtures to the Southern to buy it, and a lot of our stockholders were old Virginia money, so they decided to let the N&W and Southern merge, which would be a whole southern merger, and it would be too big for either the UP or the BNSF to take over. So that is why we merged with them.*

The two railroads had very different perspectives and focal points. Once again, Dan Berman added helpful information:

The Southern was a very competitive railroad and a very innovative railroad. The N&W was just the other side of the coin. All they knew how to do was haul coal downhill from Bluefield, West Virginia, to Norfolk. Although let me be clear: they did well with that.

On June 1, 1999, the titan got larger: Conrail (composed of the ruins of railroads such as the PRR, New York Central, Lehigh Valley, Reading, Erie Lackawanna and so on) was taken over by CSX and Norfolk Southern. The Norfolk Southern got most of what used to be the Pennsylvania Railroad mainline.

Norfolk Southern storage and repair facility, Enola Yards, 2012. *Photo by Caseyjonz.*

As of 2014, Norfolk Southern operations in Georgia included 1,719 miles of track, 618 bridges, 2,734 grade crossings (public and private), 4,735 NS employees and 2,450 railroad retirement recipients. At ATLANTA-INMAN YARD, more than seventy-five freight trains move through this major southeastern rail hub each day, hauling commodities vital to the lives of Georgia residents, according to the Norfolk Southern in Georgia fact sheet available at the company's website. (This information and more can be found at http://www.nscorp.com/content/dam/nscorp/get-to-know-ns/about-ns/state-fact-sheets/ga-state-fact-sheet.pdf.)

In 2016, Canadian-Pacific attempted a hostile takeover of Norfolk Southern but abandoned its plans in April 2016 in the face of increased regulatory scrutiny from the Obama administration.

The dwindling of the coal business is an issue facing Norfolk Southern in 2016. As Dan Berman recently commented:

> *Now, this coal business is eating Norfolk Southern alive. We've lost about*
> *35 percent of our coal business. 'Cause a lot of these power plants are*

converting to natural gas, and there is nothing you can do about that—it's cheaper, and it doesn't produce as much pollution.

Craig Bicknell suggested that Norfolk Southern can survive the drop in coal shipments through other markets:

The reduction in coal caught everyone by surprise. Not just for Norfolk Southern but for all railroads. As a matter of fact, it caught coal producers by surprise, as well.

So, how does Norfolk Southern weather it? First of all, Norfolk Southern was already known as one of the most diversified of all of the railroads, in its product mix. Although coal was still a big part of that, intermodal was a growing part, automotive—finished vehicles and auto parts was big, it also handled grain, it has a huge lumber presence in the South, grains in the Midwest and steel making. And it is continuing to do that today.

Ethanol, because of its unique features, cannot be transported by pipeline, unlike gasoline. So, tanker trucks and trains are the best way to move that stuff. So, Norfolk Southern became a big provider of unit trains for ethanol.

And then the next thing that came out was when Bakken really started going big—the Bakken region for oil production—there weren't any pipelines in North Dakota. So, the railroads said, "Hey, we've got some tracks up there, and we've got tank cars," because the ethanol boom sort of fizzled a bit. So, there were all these tank cars that weren't being used to transport ethanol—they could be used to transport crude oil out of North Dakota, down to Cushing, Oklahoma. And you had that flexibility with tank cars—you could send it to refinery A today on the West Coast, refinery B on the East Coast, to refinery C on the Gulf coast. You weren't limited by any capacity issues with pipelines.

Amtrak

Amtrak was formed on May 1, 1971, out of the wreckage of passenger service in the United States. It was (and is) a strange public/private conglomeration, receiving government funding but acting as a private corporation. Of the twenty-six railroads still offering intercity passenger routes in 1971, twenty of them turned them over to Amtrak. Others, such as the Southern Railway, followed suit later in the decade.

Amtrak Crescent sleeping car. *Photo by Robert C. Jones.*

Amtrak operates four trains in Georgia, each operating one round trip a day. The Crescent operates between New York and New Orleans and makes stops in Georgia at Atlanta, Gainesville and Toccoa. From Atlanta to New York, sleeper service is available. I've taken the Crescent many times from Atlanta to Thirtieth Street Station in Philadelphia and enjoyed the sleeper service, as well as the dining car food. I proposed to my wife, Debra, on the Crescent in 2003. From time to time, the Crescent is on time. In Georgia, the Crescent operates on Norfolk Southern track.

The other three Georgia trains operate on the coast—Silver Star, Silver Meteor and Palmetto. All three operate on tracks owned by CSX. The Silver Star operates between New York and Tampa/Miami and stops in Savannah and Jesup, Georgia. The Silver Meteor operates between New York City and Miami and also makes stops in Savannah and Jesup, Georgia. The Palmetto operates between New York and Savannah. A fourth train, the Auto Train, operates between Lorton, Virginia, and Orlando but makes no stops in Georgia.

MARTA

The Metropolitan Atlanta Rapid Transit Authority was formed in 1971 as a bus-only system. In 1975, construction began on a heavy rail system that would eventually result in forty-eight miles of track and thirty-eight train stations.

The first trains began operation on June 30, 1979. I can remember (even for this grizzled veteran of Northeast commuter rail and subways) the sense of excitement that my family had as we boarded the train from East Lake to Five Points. The trains were so *clean* and so *quiet*.

The heavy-rail portion of MARTA has been plagued with funding problems (no state funds), operational problems and management problems during its thirty-seven-year history, but it remains a shining star of the Atlanta Metropolitan Area transportation infrastructure.

The main difficulty is that MARTA operates mostly in Fulton, Clayton and DeKalb Counties, with no trains going to the "rich" (and highly populated) suburbs in Cobb and Gwinnett Counties (both counties turned down MARTA

One of the first trains to operate on the east/west line in 1979. *Photo by Robert C. Jones.*

in early referendums—1965 in Cobb, 1971 in Gwinnett). Thus, MARTA lacks political leverage outside Atlanta itself. A solution that has long been sought is some sort of regional transportation authority that has real power to make rail expansion decisions, but so far, such a thing doesn't exist.

Daily rail ridership on MARTA is about 190,000. It remains the only commuter rail system in the state of Georgia.

SHORT LINE RAILROADS IN GEORGIA

Georgia has twenty-nine short lines operating within its confines, all of them considered Class III railroads. The list here, provided by the Georgia Department of Transportation website, shows the railroad name, with the owner in parentheses (this information can be found at http://www.dot. ga.gov/InvestSmart/Rail/Documents/StateRailPlan/2015GeorgiaStateR ailPlan-1-26-16.pdf).

- Athens Line (B.R. Anderson)
- CaterParrott Railnet (CaterParrott Railnet)
- Chattahoochee Bay Railroad (Genesee and Wyoming Inc.)
- Chattahoochee Industrial Railroad (Genesee and Wyoming Inc.)
- Chattooga and Chickamauga Railway Company (Genesee and Wyoming Inc.)
- Columbus & Chattahoochee (Genesee and Wyoming Inc.)
- First Coast Railroad (Genesee and Wyoming Inc.)
- Fulton County Railway, LLC (OmniTRAX)
- Georgia & Florida Railway, LLC (OmniTRAX)
- Georgia Central Railway, LP (Genesee and Wyoming Inc.)
- Georgia Northeastern Railroad Company Inc. (Independent)
- Georgia Southern Railway (Pioneer Railcorp)
- Georgia Southwestern Railroad Inc. (Genesee and Wyoming Inc.)
- Georgia Woodlands Railroad, LLC (OmniTRAX)
- Golden Isles Terminal Railroad Inc. (Genesee and Wyoming Inc.)
- Golden Isles Terminal Wharf (Genesee and Wyoming Inc.)
- Great Walton Railroad Company Inc. (B.R. Anderson)
- Hartwell Railroad Company (B.R. Anderson)
- Heart of Georgia Railroad Inc. (Atlantic Western Transportation)
- Hilton and Albany (Genesee and Wyoming Inc.)
- Louisville and Wadley (Independent)

- Ogeechee Railway (Independent)
- Riceboro Southern Railway, LLC (Genesee and Wyoming Inc.)
- Sandersville Railroad (Independent)
- Savannah Port Terminal Railroad Inc. (Genesee and Wyoming Inc.)
- Southern Electric Railroad Company Inc. (Southern Company)
- St. Marys Railroad (Independent)
- St. Marys West Railway (Independent)
- Valdosta Railway, LP (Genesee and Wyoming Inc.)

Tourist Railroads

There are three tourist railroads operating in Georgia, as well as a fourth that makes excursions into Georgia from Tennessee.

Blue Ridge Scenic Railway: Part of the Georgia Northeastern Railroad (which runs from Marietta to Mineral Bluff, Georgia), the Blue Ridge Scenic Railway runs from Blue Ridge, Georgia, to McCaysville, Georgia (twenty-six-mile round trip). It was established by Wilds Pierce with assistance from my good friend Richard Hillman in 1998. In 2015, SR Transportation

Locomotive power for the Blue Ridge Scenic Railway, 2015. *Photo by Robert C. Jones.*

Holdings, LLC purchased Georgia Northeastern Railroad from Wilds Pierce, including the Blue Ridge Scenic Railway. At this writing, it intends on continuing operation of the tourist railroad.

SAM SHORTLINE: The SAM Shortline is operated by the Georgia Department of Natural Resources and runs from Cordele, Georgia, to Plains, Georgia, via Georgia Veterans State Park and Americus. The tourist train runs on the nineteenth-century Savannah, Americus & Montgomery Railroad right of way.

SAINT MARYS EXPRESS: The Saint Marys Express operates on the Saint Marys Railroad, in the town of the same name (near Cumberland Island). The excursion lasts for about one hour and fifteen minutes.

TENNESSEE VALLEY RAILROAD MUSEUM: The Tennessee Valley Railroad Museum (TVRM) operates two short-line (Chattooga & Chickamauga Railway) excursions into Georgia. One operates between Chattooga and Chickamauga, and the second operates between Chattanooga and Summerville. I've spoken before in the magnificent railroad depot in Summerville, for the Chattooga County Historical Society.

In addition to these four, short rides are offered at Stone Mountain Park; the Southeastern Railway Museum in Duluth, Georgia; and the Georgia State Railroad Museum in Savannah, Georgia.

ATLANTA STREETCAR

Atlanta Streetcar service began on December 30, 2014, in downtown Atlanta, running on a 2.7-mile loop. This represents the first streetcar service in Atlanta since 1949.

All rides were free until January 1, 2016, when one dollar became the ticket price. Ridership plunged by 50 percent almost overnight.

In September 2015, the Federal Transit Administration criticized the Atlanta streetcar system regarding safety, reporting practices and poor management. More recently, when the Georgia DOT threatened to shut the system down over similar concerns, the city came up with a plan to address the problems.

Often criticized as being the "road to nowhere," the City of Atlanta has plans to expand the system in the future.

Passenger Trains in the Twenty-First Century

One of the great puzzles to people from the North who visit or move to Georgia is the apparent hostility to commuter rail, especially in light of boondoggle (and extremely expensive) projects like adding a toll lane to I-75 north of Atlanta. (Drive up I-75 from I-285 and look at the massive infrastructure that is being put into place for the toll lane project. That infrastructure could just as easily have been used for light rail running down I-75.)

The hostility to commuter rail is especially puzzling considering the rich passenger rail heritage in the state, involving the W&A, the Central Railway of Georgia, the Southern Railway, Seaboard Coast Line and so on.

There has been talk about building an Atlanta Multi-Modal Passenger Terminal in downtown Atlanta (the Gulch) for years. The idea is that MARTA, Amtrak, various suburban bus companies and more could all use the same terminal. This has never gotten past the planning stage. Of course, Atlanta used to have *two* multimodal passenger stations: Atlanta Union Station (torn down in 1972) and Terminal Station (also destroyed in 1972).

Various regional boards and other commissions have proposed inter-city passenger railroad lines in Georgia, including:

- Atlanta–Athens–Augusta
- Atlanta–Birmingham
- Atlanta–Chattanooga
- Atlanta–Columbus
- Atlanta–Macon–Albany
- Atlanta–Macon–Cordele–Valdosta
- Atlanta–Macon–Cordele–Waycross
- Atlanta–Macon–Savannah
- Augusta–Savannah
- Columbus–Macon–Savannah
- Valdosta–Savannah

One of the ironies is that all of these routes were served by passenger rail by the end of the nineteenth century, but they are all gone now (except Atlanta to Birmingham via Amtrak and the coastal trains that pass through Savannah from New York to Florida).

Expansion of commuter rail in the Atlanta area has also been proposed by various boards and commissions and could comprise a mixture of heavy rail (à la MARTA) and light rail:

- Canton–Atlanta
- Gainesville–Atlanta
- Athens–Atlanta
- Madison–Atlanta
- Macon–Atlanta
- Senoia–Atlanta
- Bremen–Atlanta
- Rome–Atlanta
- Cartersville–Atlanta

It is unlikely that any of these lines will ever be built now that the state has gone down the path of the "Lexus Lanes," which benefit rich people with cars rather than poor people without cars.

Sites Associated with Georgia Railroads

Sites Associated with Georgia Railroads	Address or Location
1849 W&A Depot (Dalton)	110 Depot Street, Dalton, 30720
1849 W&A Depot (Ringgold)	155 Depot Street, Ringgold, Georgia, 30736
1849 W&A Depot and Museum	101 Public Square, Adairsville, Georgia, 30103
A&WP Railroad depot (site of the beginning of the Battle of Brown's Mill)	60 East Broad Street, Newnan, Georgia
Allatoona Pass (W&A)	Old Allatoona Road, Emerson, Georgia
Central of Georgia Railroad: Savannah Shops and Terminal Facilities	West Broad and Liberty Streets, Savannah, Georgia
Georgia State Railroad Museum	655 Louisville Road, Savannah, Georgia, 31401
Southeastern Railroad Museum	3595 Buford Hwy, Duluth, Georgia, 30096

Sites Associated with Georgia Railroads	Address or Location
Southern Museum (home of the W&A locomotive General, and the archives of the Southern Railway)	2628 Cherokee Street, Kennesaw, Georgia, 30144
Tunnel Hill Visitor's Center and the 1849 Tunnel Hill W&A Depot	215 Clisby Austin Road, Tunnel Hill, Georgia

Appendix I

TIMELINE

Date	Event
December 24, 1830	American-built locomotive Best Friend of Charleston operates on track in Charleston owned by the South Carolina Canal and Railroad Company.
1833	Georgia Railroad is charted in Augusta, Georgia.
December 20, 1833	Central Railroad and Canal Company is chartered.
December 21, 1836	The Georgia legislature authorizes the building of a state-owned railroad from Chattanooga to Terminus, Georgia (now Atlanta). It will be called the Western & Atlantic.
1837	Financial panic, partly because of the realization that canals are no longer a growth industry.
October 1843	Central Railroad track is completed from Savannah to Macon.
September 14, 1845	Georgia Railroad is completed from Augusta to Atlanta.
September 4, 1846	Macon & Western is completed from Macon to Atlanta.

Date	Event
May 9, 1850	The first train travels over the entire length of the W&A, from Atlanta to Chattanooga.
1852	The East Tennessee & Georgia Railroad is completed from Loudon, Tennessee, to Dalton, Georgia, where it links up with the W&A.
May 1854	Atlanta & West Point is completed from Atlanta to West Point, Georgia.
1862	Colonel William Wadley is appointed supervisor of railroads by the Confederate government.
April 12, 1862	The "Great Locomotive Chase" takes place on the Western & Atlantic.
1864	Western & Atlantic car shed and other railroad infrastructure are destroyed in Atlanta by William Tecumseh Sherman.
1868	Radical Republican Rufus Bullock, president of the Macon & Augusta Railroad, is elected governor of Georgia.
January 1870	Bullock appoints Foster Blodgett as superintendent of the Western & Atlantic Railroad. Blodgett fires Captain William Fuller for "being a Democrat."
1871	Second Union Station in Atlanta begins construction on the site of the old Western & Atlantic car shed.
October 13, 1871	With Federal troops removed from Georgia in July 1870, Rufus Bullock resigns as governor of Georgia and moves back north.
May 1877	Rufus Bullock is extradited from New York to Georgia to stand trial for corruption and malfeasance but is exonerated.
1879	Henry Bradley Plant purchases the Atlantic & Gulf Railroad (237 miles long, Savannah to Bainbridge, with branches to Albany and Florida). The line is renamed Savannah, Florida & Western Railway. This is the beginning of the Plant System.

Date	Event
1880	Louisville & Nashville purchases a controlling interest in the Nashville, Chattanooga & St. Louis Railway.
1881	Savannah, Florida & Western Railway builds a seventy-five-mile line from Waycross to Jacksonville, Florida. Colonel William M. Wadley leases the Georgia Railroad (including the A&WP and the Western Railway of Alabama), assigning half of the properties to the Central Railroad and half to the L&N.
1882	Death of Colonel William Wadley. General E. Porter Alexander is appointed president of the Central Railroad.
Late 1883	Georgia Pacific Railroad under President John B. Gordon opens a line from Atlanta to Birmingham.
1886	Henry Bradley Plant starts a steamship line. John Inman and associates gain control of the Richmond Terminal Company.
1888	Richmond Terminal Company gains a controlling interest in the Central Railroad.
1890	The Plant System operates on 1,500 miles of track in the Southeast, with 522 miles in Georgia.
March 3, 1892	Mrs. Rowena Clarke of Charleston, South Carolina, files suit against the Richmond Terminal Company on behalf of her fifty shares of Central Railroad stock.
1893	Financial Panic of 1893.
February 1893	John Pierpont Morgan takes over the financial affairs of the Richmond Terminal Company, which had been in receivership since 1892. The Richmond Terminal Company controls six thousand miles of track.

Date	Event
1894	Southern Railway is formed as a result of Morgan's financial reorganization of the Richmond Terminal Company. It will encompass about 4,800 miles of track.
October 1894	First shareholders meeting of the Southern Railway is held, and a board (with three Morgan appointees included) is elected, with Samuel Spencer as president.
1895	Central Railroad purchases the Macon & Northern Railroad. Predecessors of the Seaboard Air Line Railway purchase the Savannah, Americus & Montgomery Railway, giving them a competitive foothold against the Central Railroad.
1897	Tallulah Falls Railway is formed. It operates in receivership for most of its life until 1961, when it dies.
February 1898	L&N Railroad buys the 50 percent share of the Georgia Railroad lease owned by Thomas & Ryan and now controls the Georgia Railroad, the Western Railway of Alabama and the Atlanta & West Point.
1899	After the death of Henry Bradley Plant, much of the Savannah, Florida & Western Railway is sold to the Atlantic Coast Line. Seaboard Air Line Railway is created by John Skelton Williams with a merger of Florida Central & Peninsular Railroad, the Seaboard Air Line and the Georgia & Alabama Railroad.

Date	Event
	Atlantic Coast Line acquires a controlling interest in the L&N and thus also controls the Georgia Railroad, the A&WP and the Western & Atlantic.
1902	Thirty-six different trolley-car companies in Atlanta are consolidated into the Georgia Railway & Electric Company.
	Atlanta Belt Line Railway (loop) is completed.
1905	Atlanta, Birmingham & Atlantic Railroad is organized.
	Southern Railway Atlanta Terminal Station opens.
circa 1908	Southern Railway office building opens across from Atlanta Terminal Station.
1916	Southern Railway, Central of Georgia Railway, Atlanta, Birmingham & Atlantic Railway and the West Point Route use the Atlanta Terminal Station (other railroads are still using Union Station).
1918	Peachtree (Brookwood) Station opens as a commuter station on the Southern Railway. It would later serve as the Amtrak Station in Atlanta.
1919	NC&StL Railway renews its W&A Railroad lease from the State of Georgia.
1925	Crescent Limited begins service on Southern Railway–owned track.
1938	Gainesville Midland Railroad runs gasoline-powered buses on the rails for passenger service.
July 17, 1947	The Nancy Hanks makes its inaugural run on the Central of Georgia Railway between Savannah and Atlanta.
1956	Walt Disney Productions films *The Great Locomotive Chase* on the Tallulah Falls Railway.

Date	Event
1957	NC&StL is absorbed into the Louisville & Nashville Railroad (controlled by the Atlantic Coast Line Railroad).
June 17, 1963	The St. Louis–San Francisco Railway sells its stock in the Central of Georgia Railway to the Southern Railway.
1967	Atlantic Coast Line merges with the Seaboard Air Line Railroad to form the Seaboard Coast Line Railroad (SCL), which adds the old Western & Atlantic to the fold.
Early 1970s	SCL merges with the Louisville & Nashville Railroad and the Clinchfield Railroad and is now the Family Lines System. The Georgia Railroad continues to be operated as a separate company, with the Family Lines holding the lease.
1971	Amtrak takes over most passenger service in the South.
1972	Atlanta Terminal Station and Atlanta Union Station are demolished.
1979	Southern Railway turns over its passenger service to Amtrak.
1982	Norfolk Western and Southern Railway merge, creating the Norfolk Southern Railway.
1983	Family Lines purchases the railroad part of the Georgia Railroad and Banking Company.
1986	CSX Transportation is formed when Seaboard Coast Line merges with the Chessie System. Georgia Railroad Bank merges with First Union (now Wells Fargo).
December 30, 2014	Atlanta Streetcar service begins in downtown Atlanta, running on a 2.7-mile loop.

Appendix II

THE W&A RIDES AGAIN

1962 CENTENNIAL RUN OF THE GENERAL

On April 14, 1962, the reconditioned General ran under its own steam from Tilford Yard in Atlanta to Chattanooga. The run was in commemoration of the 100th anniversary of the Andrews Raid on April 12, 1862. *Trains* magazine (July 1962) estimated that 100,000 people viewed the centennial run of the General, including crowds of 10,000 in Kennesaw (where the train was stolen) and 12,000 in Ringgold (where the chase ended).

The trip from Atlanta to Chattanooga took about eight hours. The General is reported to have reached a speed of fifty miles per hour between Ringgold and Chattanooga. Kennesaw went so far as to erect false storefronts on the west side of Main Street to give the town a fuller and more "old time" feeling. Period dress was *de rigeur*.

RETURN OF THE GENERAL TO KENNESAW

After the centennial run of the General in 1962, it was returned to Chattanooga for display in Union Depot. The General repeated its centennial run under its

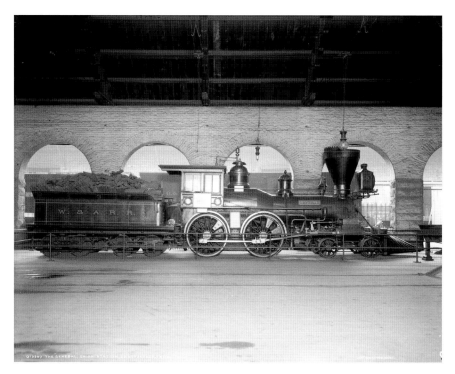

"The General, Union Station, Chattanooga, Tenn.," circa 1907. *Courtesy Library of Congress.*

own steam in 1963. During September 17–21, 1966, the General ran under its own steam for the last time near Paducah, Kentucky.

Starting in 1967, a three-year dispute raged between Chattanooga, Tennessee, and the State of Georgia/L&N Railroad over the ownership of the General. The dispute started in February 1967, when the L&N Railroad agreed to give the General to the State of Georgia. This gesture was probably done to encourage renewal of the lease for the W&A right of way, which was set to expire on December 27, 1969.

On April 5, 1967, Governor Lester Maddox signed a resolution calling for the return of the General to Kennesaw. It would be three more years before the ensuing legal battle was resolved and almost two years more after that before the General was ensconced in the museum in Kennesaw.

Date	Activity
September 12, 1967	The General is en route to Kennesaw to participate in a three-day festival when it is stopped at 1:30 a.m. by a party led by Chattanooga mayor Ralph Kelly. The three-year court battle begins.
December 16, 1967	The General is moved to the Louisville shops of the L&N (approved by U.S. District judge Frank W. Wilson).
January 4, 1969	U.S. District judge Frank W. Wilson rules that the L&N owns the General.
May 21, 1970	U.S. Court of Appeals for the Sixth District upholds the lower court ruling.
November 9, 1970	The Supreme Court of the United States refuses to overturn a lower court ruling, granting ownership of the General to the L&N Railroad.

In about 1971, the Frey family of Kennesaw donated the building and land for the Big Shanty Museum to the City of Kennesaw. On February 18, 1972, the General was presented to the State of Georgia (accepted by Governor Jimmy Carter) by the L&N railroad and moved to Kennesaw on a railroad flatcar, arriving around 6:00 p.m. The next day, the General was transferred to the back of a truck and eased into the back of the Big Shanty Museum (now the Southern Museum of Civil War and Locomotive History). Speakers on that dreary February day included Kennesaw mayor Louis Watts.

On April 12, 1972, the Big Shanty Museum was opened to the public in the old Frey cotton mill, 110 years after the Andrews Raid. The General had come home to Kennesaw!

In 2003, when the Southern Museum of Civil War and Locomotive History opened, the General hadn't moved—the new forty-thousand-square-foot museum was built around the old Frey cotton gin.

RAILROADS OF GEORGIA QUIZ

1. T/F—Grant Park in Atlanta (home of the Atlanta Zoo) was named after President Ulysses S. Grant.
2. T/F—The Western & Atlantic was the first railroad chartered in Georgia.
3. T/F—The chief engineer of the Georgia Railroad when it was originally built went on to be president of the Pennsylvania Railroad.
4. T/F—The Southern Railway was created by New York financier Cornelius Vanderbilt.
5. T/F—The Nancy Hanks was a famous passenger train on the Southern Railway.
6. T/F—In 1999, Conrail was divided up between Norfolk Southern and CSX.
7. T/F—There are no passenger trains running in Georgia as of 2016.
8. T/F—John Skelton Williams was a key figure in creating the Seaboard Air Line Railroad.
9. T/F—The 1956 Disney film *The Great Locomotive Chase* was filmed on the Tallulah Falls Railway.
10. T/F—Colonel William M. Wadley at one time purchased the lease on the Georgia Railroad with his own personal funds.
11. T/F—"Sherman's neckties" referred to proper dress for formal military gatherings after the Civil War.
12. T/F—William Tecumseh Sherman took Atlanta by storming the fortifications built by Lemuel Grant.
13. T/F—MARTA is a bus-only transportation system in Atlanta, Georgia.

14. T/F—The drop in coal haulage is a matter of concern for most Class I railroads, especially Norfolk Southern.
15. T/F—The Orange Blossom Special was a famous passenger train on the Seaboard Air Line Railway.
16. T/F—The twentieth century was a time of railroad creation by individual entrepreneurs.
17. T/F—The first lease of the Western & Atlantic Railroad was secured by a consortium headed by former Georgia governor Joseph Brown.
18. T/F—William Tecumseh Sherman once said that the Civil War was won because of the Georgia Railroad.
19. T/F—Entrepreneur Thomas Clyde is closely associated with the Piedmont Air Line.
20. Name a railroad that ran (roughly) from Atlanta to Macon but was *not* named the Macon & Western.

Answers: 1: F; 2: F; 3: T; 4: F; 5: F; 6: T; 7: F; 8: T; 9: T; 10: T; 11: F; 12: F; 13: F; 14: T; 15: T; 16: F; 17: T; 18: F; 19: T; 20: Atlanta & Florida Railway

Sources

Appleton's Annual Cyclopedia for 1864. Vol. 4. New York: D. Appleton & Company, 1865.

Collection of David W. Salter. Available at the Southern Museum Archives & Library.

Collection of the Bogle family and David Ibata.

CSX in Georgia, 2015. Available at https://www.csx.com/index.cfm/about-us/state-information/georgia.

Dinsmore, Curran. *American Railways Guide for the United States.* N.p., 1851.

Georgia Department of Transportation. *Georgia State Rail Plan.* Atlanta, GA: self-published, 2015.

Jones, Robert C. *A Guide to the Civil War in Georgia.* N.p.: Createspace, 2013.

Martin, Thomas H. *Atlanta and Its Builders.* N.p.: Century Memorial Publishing Company, 1902.

Moody, John. *The Railroad Builders.* New Haven, CT: Yale University Press, 1921.

Norfolk Southern in Georgia, 2015. Available at http://www.nscorp.com/content/dam/nscorp/get-to-know-ns/about-ns/state-fact-sheets/ga-state-fact-sheet.pdf.

The Photographic History of the Civil War in Ten Volumes. Vol. 5, *Forts and Artillery.* N.p.: Review of Reviews Company, 1911.

Pittenger, William. *Capturing a Locomotive.* N.p.: National Tribune, 1881.

Statement for Financial Operations of Railroads for the Year Ending June 30, 1908. New York: Railroad Age Gazette, 1909.

Thirty-Fifth Report, Part I of the Railroad Commission of Georgia, 1908. New York: Railroad Age Gazette, 1909.

The War of the Rebellion: A Compilation of the Official Records of the Union and Confederate Armies. 128 vols. Washington, D.C.: Government Printing Office, 1880–1901.

Winn, Les R. *Ghost Trains & Depots of Georgia (1833–1933)*. Kennesaw, GA: Big Shanty Publishing Company, 1995.

LINKS

Georgia's Railroad History and Heritage. www.railga.com.

Library of Congress. http://hdl.loc.gov/loc.gmd/g3924c.pm001240.

———. http://hdl.loc.gov/loc.ndlpcoop/gvhs01.vhs00053.

———. http://loc.gov/pictures/resource/cph.3a20135.

———. http://www.loc.gov/pictures/item/ga0837.photos.055871p.

———. https://lccn.loc.gov/2004678720.

———. https://lccn.loc.gov/2005681127.

———. https://lccn.loc.gov/2008679857.

———. https://lccn.loc.gov/98688799.

———. https://www.loc.gov/item/cwp2003005432/PP.

———. https://www.loc.gov/item/cwp2003005462/PP.

———. https://www.loc.gov/item/det1994009181/PP.

———. https://www.loc.gov/item/det1994009932/PP.

———. https://www.loc.gov/item/det1994012847/PP.

———. https://www.loc.gov/item/fsa1997003448/PP.

———. https://www.loc.gov/item/fsa2000051408/PP.

———. https://www.loc.gov/item/fsa2000051412/PP.

———. https://www.loc.gov/item/ga0126.

———. https://www.loc.gov/item/ga0356.

———. https://www.loc.gov/item/ga0555.

———. https://www.loc.gov/item/ga0580.

———. https://www.loc.gov/item/ggb2005024620.

———. https://www.loc.gov/item/hec2008007247.

———. https://www.loc.gov/item/npc2008013313.

———. https://www.loc.gov/item/npc2008013314.

INDEX

ABOUT THE AUTHOR

Robert C. Jones served as president of the Kennesaw Historical Society for twenty-one years (1994–2015), and also served as a member of the executive board of the Kennesaw Museum Foundation for seventeen years (1998–2015). The Museum Foundation helped fund the forty-five-thousand-square-foot Southern Museum of Civil War and Locomotive History in Kennesaw, Georgia. He has written more than forty books on historical themes and several books on "Old West" themes.

Robert C. Jones is an ordained elder in the Presbyterian Church. He has written and taught numerous adult Sunday school courses. He is also the author of a number of books on Christian history and theology topics (for a list, see http://rcjbooks.com/christian_history).

In 2005, Robert co-authored a business-oriented book, *Working Virtually: The Challenges of Virtual Teams*. In 2013, Robert authored a book on World War I titled *The Top 10 Innovations of World War I* and published *The Leo*

Beuerman Story: As Told by His Family. In 2014, Robert published *Ghost Towns and Mills of the Atlanta Area*. In 2016, he published *The Top Innovations of World War II*.

OTHER WORKS BY THE AUTHOR

HISTORICAL BOOKS:
The Battle of Allatoona Pass: The Forgotten Battle of Sherman's Atlanta Campaign
The Battle of Chickamauga: A Brief History
The Battle of Griswoldville: An Infantry Battle on Sherman's March to the Sea
Bleeding Kansas: The Real Start of the Civil War
Civil War Prison Camps: A Brief History
Colonial Georgia: 1733–1800
The Confederate Invasion of New Mexico
Conspirators, Assassins, and the Death of Abraham Lincoln
The End of the Civil War: 1865
The End of the Civil War in Georgia: 1865
Famous Songs of the Civil War
The Fifteen Most Critical Moments of the Civil War
George Washington and the Continental Army: 1777–1778
Great Naval Battles of the Civil War
A Guide to the Civil War in Alabama
A Guide to the Civil War in Georgia
Heroes and Heroines of the American Revolution
Lost Confederate Gold
McCook's Raid and the Battle of Brown's Mill
The Pennsylvania Railroad: An Illustrated Timeline
The Reading Railroad: An Illustrated Timeline
Retracing the Route of Sherman's Atlanta Campaign (expanded edition)
Retracing the Route of Sherman's March to the Sea (expanded edition)
The Ten Best—and Worst—Generals of the Civil War
The Top 10 Reasons Why the Civil War Was Won in the West
The Top 20 Civil War Spies and Secret Agents
The Top 20 Railroad Songs of All Time
The Top 25 Most Influential Women of the Civil War
The W&A, the General, and the Andrews Raid: A Brief History
The War of 1812: A Brief History